IMAGES
of America

LIGONIER VALLEY

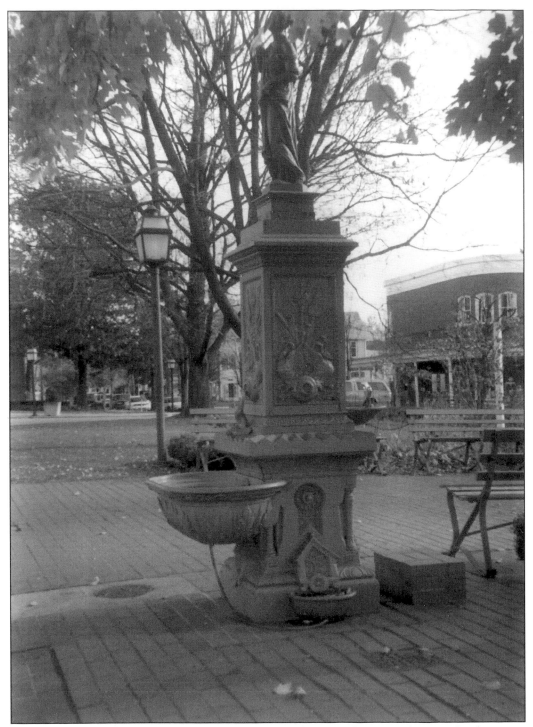

This fountain, built at the turn of the last century, features three troughs: one for dogs, one for horses, and one for humans. To the right is the renovated southeast corner of the Ligonier Diamond. (Courtesy Bruce A. Shirey.)

IMAGES
of America

LIGONIER VALLEY

Sally Shirey

ARCADIA
PUBLISHING

Copyright © 2001 by Sally Shirey
ISBN 978-0-7385-0535-0

Published by Arcadia Publishing
Charleston, South Carolina

Printed in the United States of America

Library of Congress Catalog Card Number: 2001086404

For all general information contact Arcadia Publishing at:
Telephone 843-853-2070
Fax 843-853-0044
E-mail sales@arcadiapublishing.com
For customer service and orders:
Toll-Free 1-888-313-2665

Visit us on the Internet at www.arcadiapublishing.com

Author's note: I am continuing to research the history of the Ligonier Valley. If you have further information or historical documents (photographs, postcards, memorabilia), please contact me in care of the publisher or Drummer Boy Books, 209 East Main Street, Ligonier, Pennsylvania, 15658. Thank you.

—Sally Shirey

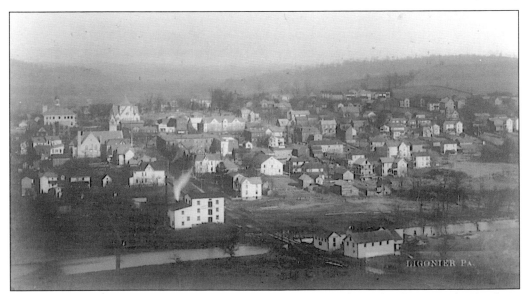

This card, postmarked in 1906, shows the Loyalhanna Creek in the foreground. The large buildings in the center, from left to right, are the public school, the Methodist church, and the Presbyterian church. Just beyond the creek, in the open area, is the site of Fort Ligonier. (Courtesy Ray Kinsey.)

CONTENTS

ACKNOWLEDGMENTS

I would like to thank the following groups and individuals for their support of this project: Wyatt and Nancy Young of Drummer Boy Books, who instigated the project at the suggestion of Phil Walters; Ray Kinsey for his incredible wealth of knowledge about the valley and his generosity in sharing it; Bethlen Home – Michael Walker; Fort Ligonier Association – Martin West and Shirley McQuillis Iscrupe; Latrobe Foundry Machine & Supply Company – Dorothy S. Hunter and Louis A. Steiner; Ligonier Borough Police Department – Chief Randy Cox; Kennywood Corporation/Idlewild Park – Mary Lou Rosemeyer; Laurel Mountain Ski Resort – Julie Donovan; Ligonier Valley Ambulance Service – Keith Stouffer; Ligonier Valley Chamber of Commerce – Rachel Roehrig and Christie Goswick; Ligonier Valley Historical Society – Lisa Hays; Ligonier Valley Library – Janet Hudson and Elaine Johns; Lincoln Highway Heritage Corridor – Olga Herbert; Martin's Specialty Shop – Hadley Martin and Mary Lou Fleming. Thanks, too, to the following individuals who lent material for the book: Ken Knupp, Doris Matthews, Bill McCollough, and Bob Ramsey. Special thanks for support, moral and otherwise, to my family and to Clark McKowen.

This book is dedicated with love to Bruce.

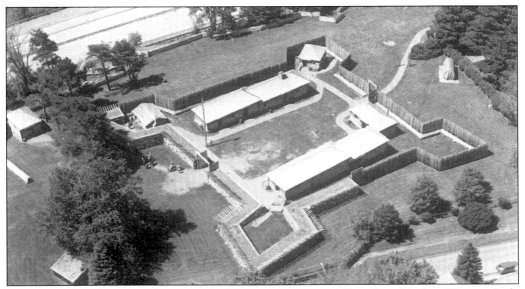

This aerial shot shows Fort Ligonier, the largest reconstructed French and Indian War stockade in America. (Courtesy Doris Matthews.)

6

INTRODUCTION

The winds of war were blowing in the mid-18th century as two great forces from Europe vied for possession of what is now western Pennsylvania. Both France and Great Britain understood that whoever controlled the Ohio Valley controlled all the resources of the Mississippi Basin. As settlers moved west in increasing numbers, few could have guessed the role the Ligonier Valley would come to play in determining the course of our nation's history.

The struggle began with the earliest explorers. French explorer Robert Chevalier de la Salle, in 1682, discovered the Allegheny, Ohio, and Mississippi Rivers and claimed all the regions drained by them. Clearly this clashed with England's claim "to all the land bordering on the Atlantic Ocean for a distance of 400 miles, extending from sea to sea."

The French took the strategic Forks of the Ohio (present-day Pittsburgh) and built Fort Duquesne, where the Allegheny and Monongahela Rivers join to form the Ohio River. Both George Washington and Edward Braddock led ill-fated attempts to evict the French from Fort Duquesne. By 1758, the English had launched a massive campaign to defeat the French by attacking their three largest forts: Louisbourg in Nova Scotia, Ticonderoga in New York, and Duquesne.

The task of capturing Fort Duquesne fell to Gen. John Forbes. His troops included provincials from Pennsylvania, Virginia, Maryland, and North Carolina, as well as 1,200 Highlanders from Col. Archibald Montgomery's regiment and a detachment of Royal Americans. The Royal American regiment was a new corps raised in the colonies. It was a largely Pennsylvania German unit, led by European officers. Lt. Col. Henry Bouquet, an officer of the Royal Americans, became Forbes's executive officer. With some 6,000 to 7,000 people, including wagoners and camp followers, Forbes knew that there would be no problem taking Fort Duquesne once he reached it. His problem was logistical: how to get through the wilderness safely, supplying food, supplies, and munitions along the way.

Forbes was certain that the key to success was establishing a line of fortified supply posts to support the expedition. These posts were located about 40 miles apart, near enough to allow the expedition to move forward or back or to wait out bad weather before moving on. The camp at Loyalhanning (named Fort Ligonier) would become the base for the final assault on Fort Duquesne.

After it was determined that the most expedient route from Raystown (now Bedford) to Fort Duquesne was across the Allegheny Mountains, construction of a military road was begun. Col. James Burd and his men set out to cut and grade the road. This meant moving boulders, building embankments where needed, and slogging through the tangled swamps and forests.

Winter came early in late 1758. The cold fall rain turned to snow, and the roads turned to mud bogs. Snows dusted both Laurel and Chestnut Ridges. Forbes arrived at Ligonier in early November and was prepared to wait until spring to attack Fort Duquesne. However, a bit of good news encouraged him to proceed: the French forces at Fort Duquesne were shorthanded and their Native American allies had left to prepare for winter. When Forbes mounted his assault on

Fort Duquesne, the French forces abandoned the fort, setting it on fire. The British took control of the site and rebuilt the fort, naming it in honor of Prime Minister William Pitt.

The Forbes campaign was successful on several levels and altered the course of American history. The French were defeated and the country was opened to British domination. If the French had been able to maintain control of the Forks of the Ohio, it is conceivable that the colonists might have been French subjects. In addition, transportation passageways were improved in Pennsylvania and the country was opened up for settlement. The "frontier" was effectively pushed west to the Ohio River.

After the Forbes campaign, Fort Ligonier remained instrumental in providing protection for settlers in the area. It was a key supply link to Pittsburgh. The fort's civilian commanders, such as Arthur St. Clair, sought to protect the settlers while working for peace with the Native Americans they were displacing. Following the Revolutionary War, settlers continued to push farther westward and conflicts with the Native Americans decreased. Ultimately, Fort Ligonier succumbed to the effects of weather and disuse and disappeared.

One

THE EARLY DAYS

The site chosen for Fort Ligonier was Loyalhanning, a Delaware Native American village. Strategically, it was an ideal site for a fort. It was set on a hill that fell away on three sides. There was a spring for water, and a clearing along the Loyalhanna Creek provided grazing for livestock. John Armstrong, with Gen. John Forbes's road detachment, declared that the breezes carried "the scent of French brandy" to the spot.

The British forces began arriving in early autumn. The Pennsylvania Regiment started building a stockade and fortified camp. Within the stockade was a square fort with storehouses, barracks, a powder magazine, and several smaller buildings.

From Fort Duquesne, the French commander watched the British forces moving westward, building fortifications. Though he was outnumbered, Capt. Francois-Marie de Marchand, Sieur de Ligneris hoped to delay the British push west until spring. On October 12, 1758, a band of French soldiers and their Native American allies attacked the partially completed Fort Ligonier. The British troops, commanded by Colonel Burd, finally routed the French after several hours. This skirmish turned out to be the final battle between the French and Native American alliance and the British in their contest for the region.

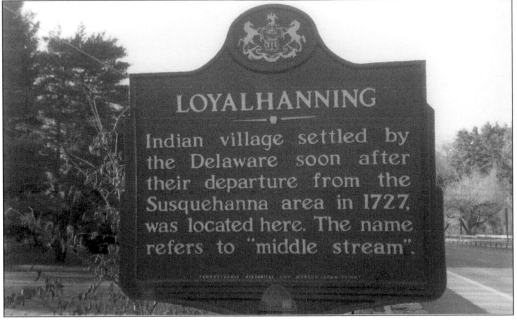

The name Loyalhanning comes from several Delaware Native American terms. The adjective *lawell* means "middle," *hanna* means "river or stream," and *ing* indicates "the place at." Thus Loyalhanning means "the place at the middle river." This is actually quite an accurate description of the area, which is about halfway between the Juniata River to the east and the Ohio River to the west, and about halfway between the Conemaugh River to the north and the Youghiogheny River to the south. (Courtesy Bruce A. Shirey.)

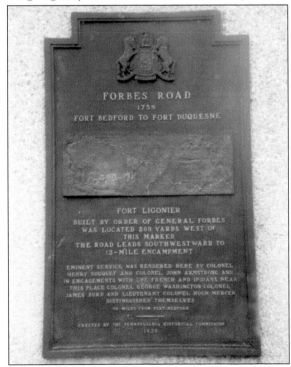

This marker, erected by the Pennsylvania Historical Commission in 1930, details the course taken by the army of Gen. John Forbes en route from Fort Bedford to Fort Duquesne. Forbes's Road was built for the sole purpose of moving his army through mountainous country and was one of the most important military roads in Colonial America. (Courtesy Bruce A. Shirey.)

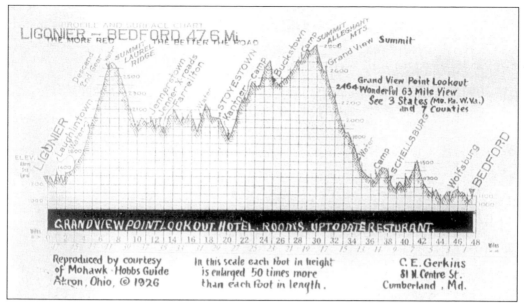

This map gives some idea of the obstacles Gen. John Forbes faced in building his new route from Bedford to Ligonier. Every mile of the terrain was wooded and overgrown with underbrush. In order to stay on higher ground, rock had to be taken away in some areas, only to be hauled to others to support the roadbed. Forbes's men called Laurel Ridge "that terrible mountain." (Courtesy Lincoln Highway Heritage Corridor.)

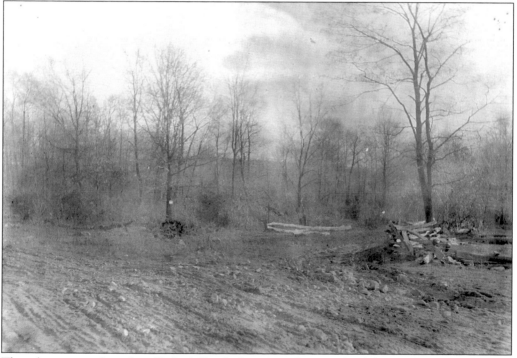

Though more modern than Forbes's Road, this 1906 photograph of three old roads at the base of Laurel Hill gives a glimpse of what the army of General John Forbes faced on its journey. Notice the rutted, rocky roadway. (Courtesy Ligonier Valley Historical Society.)

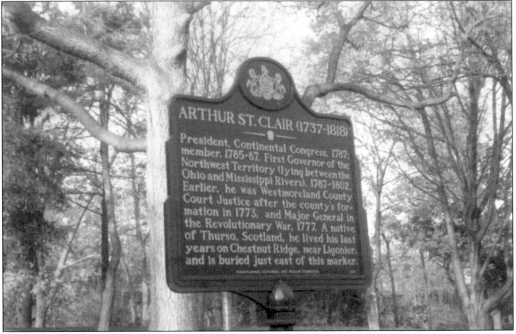

Arthur St. Clair came to America during the French and Indian War. After having served the British army with honors, he was hired by the Penn family to look after their affairs in southwestern Pennsylvania. (Courtesy Bruce A. Shirey.)

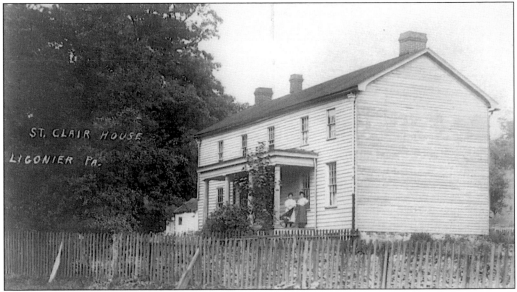

The St. Clair homestead, the Hermitage, was built on several hundred wooded acres just north of Ligonier. A statesman, Arthur St. Clair was named the civil commandant of Fort Ligonier and was instrumental in the founding of Westmoreland County. When called to duty during the Revolutionary War, he served with Gen. George Washington and reached the rank of major general. He also served as president of the Continental Congress and was appointed the first governor of the Northwest Territories. The women on the porch are not identified. (Courtesy Ray Kinsey.)

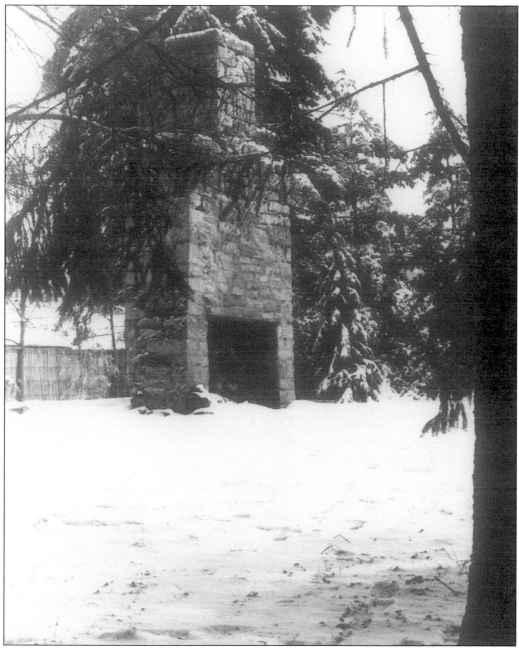

Gen. Arthur St. Clair frequently had to use his own resources and those of his wife, Boston socialite Phoebe Bayard, to finance his governmental appointments. He organized and funded the Frontier Rangers in 1774. In addition, the financing for his troops in the Northwest Territories often came from his own pocket. Though repayment was promised, it did not come. His properties, including the Hermitage, were sold at sheriff's sales between 1808 and 1810, leaving the St. Clairs with few personal possessions. Even his government pension was attached to pay his creditors. This photograph, taken in 1976, shows the remains of the Hermitage. The chimney has since been torn down. (Photograph by Ray Kinsey, courtesy Ligonier Valley Historical Society.)

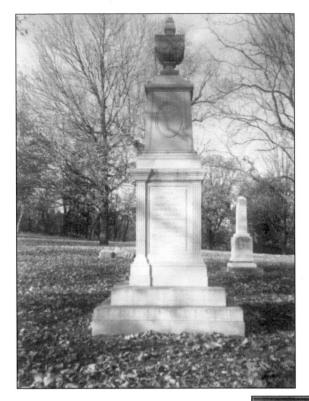

Following the sheriff's sales, the St. Clairs moved to a small home on the Chestnut Ridge along the State Road. When the Philadelphia–Pittsburgh Turnpike was begun in 1815, it followed the Loyalhanna Creek, bypassing the St. Clair home and further cutting off the family. Arthur St. Clair died on August 31, 1818, having fallen from a wagon on his way to town. Phoebe St. Clair died just 18 days later. The couple are buried in St. Clair Park, Greensburg. (Courtesy Bruce A. Shirey.)

In 1832, the Masonic Society of Greensburg erected a sandstone monument over the graves of Arthur and Phoebe St. Clair. It was replaced with granite in 1913. The text reads, "The earthly remains of Major-General Arthur St. Clair are deposited beneath this humble monument which is erected to supply the place of a nobler one due from his country. He died August 31, 1818, in the 84th year of his age." (Courtesy Bruce A. Shirey.)

THE
earthly remains
or
Major-General
ARTHUR ST. CLAIR,
are deposited
beneath this humble monument
which is
erected to supply the place
of a nobler one
due from his country.
He died August 31,
1818,
in the 84th year of his age.

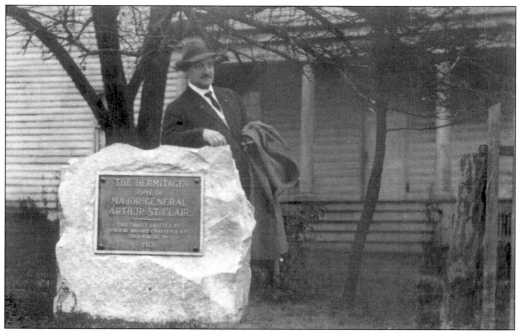

An unknown gentleman leans on a marker at the front of the Hermitage. The text reads, "The Hermitage – Home of Major General Arthur St. Clair. This tablet erected by Phoebe Bayard Chapter D.A.R., Greensburg, PA, 1912." This marker has been moved to the Fort Ligonier grounds in front of the museum. (Courtesy Ray Kinsey.)

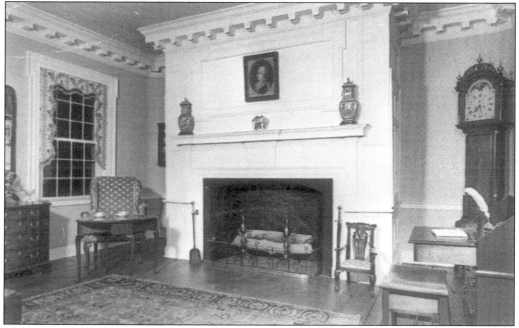

This undated postcard shows the last remaining room from the Hermitage, on display at Fort Ligonier. It gives some indication of the luxury the St. Clairs enjoyed at one time. As agent for the Penn family, Arthur St. Clair was able to amass a fortune that included some 10,000 acres of land, an iron furnace, and a gristmill. (Courtesy Ray Kinsey.)

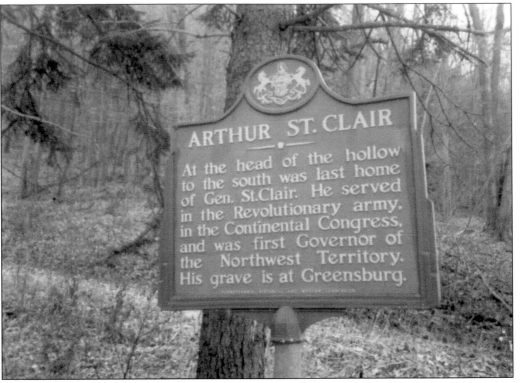

ARTHUR ST. CLAIR
At the head of the hollow to the south was last home of Gen. St.Clair. He served in the Revolutionary army, in the Continental Congress, and was first Governor of the Northwest Territory. His grave is at Greensburg.

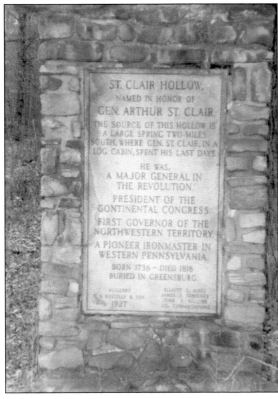

ST. CLAIR HOLLOW,
NAMED IN HONOR OF
GEN. ARTHUR ST. CLAIR
THE SOURCE OF THIS HOLLOW IS A LARGE SPRING TWO MILES SOUTH, WHERE GEN. ST. CLAIR, IN A LOG CABIN, SPENT HIS LAST DAYS.
HE WAS,
A MAJOR GENERAL IN THE REVOLUTION.
PRESIDENT OF THE CONTINENTAL CONGRESS.
FIRST GOVERNOR OF THE NORTHWESTERN TERRITORY.
A PIONEER IRONMASTER IN WESTERN PENNSYLVANIA.
BORN 1736 – DIED 1818
BURIED IN GREENSBURG.

These markers are located on Route 30 at the base of St. Clair hollow. The Chestnut Ridge land to which these markers refer had been granted to Gen. Arthur St. Clair in September 1783 by a special resolve of the General Assembly of Pennsylvania. St. Clair believed that "no man has a right to withhold his services when his country needs them. Be the sacrifice ever so great, it must be yielded upon the altar of patriotism." For St. Clair the sacrifice was great. (Both images courtesy Bruce A. Shirey.)

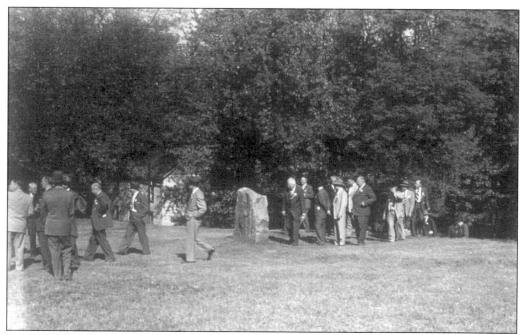

In 1927, John Jacob Hughes bought the lot on which the heart of Fort Ligonier was located and presented the deed to the Daughters of the American Revolution. In 1931, the DAR purchased the adjoining lot. In 1934, a monument was erected to mark the site of the fort. Here, a group of businessmen survey the marker. (Courtesy Ligonier Valley Chamber of Commerce.)

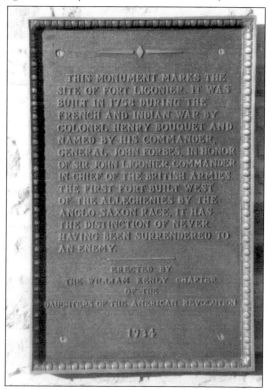

The Fort Ligonier marker reads, "This monument marks the site of Fort Ligonier. It was built in 1758 during the French and Indian War by Colonel Henry Bouquet and named by his commander General John Forbes in honor of Sir John Ligonier, Commander-in-Chief of the British Armies. The first fort built west of the Alleghenies by the Anglo-Saxon race, it has the distinction of never having been surrendered to an enemy. Erected by the William Kenly Chapter of the Daughters of the American Revolution. 1934." (Courtesy Bruce A. Shirey.)

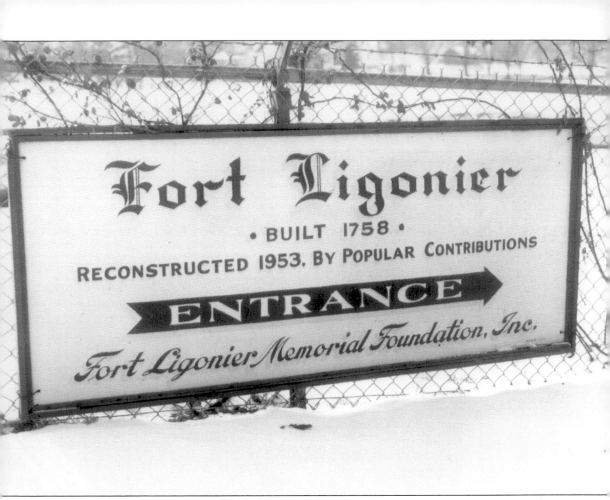

In November 1946, the Fort Ligonier Memorial Foundation was chartered under the auspices of the Ligonier Valley Chamber of Commerce. In 1954, reconstructed officers quarters and the north and west bastions were opened to the public. The project was entirely funded with private funds. A donation of land by the Ligonier Valley Rail Road allowed part of the outer retrenchment and gun battery to be rebuilt. (Courtesy Ligonier Valley Chamber of Commerce.)

In 1948, the Daughters of the American Revolution presented the deeds for the fort site to the Fort Ligonier Memorial Foundation. Fort curator Jacob Grimm worked with architect Charles M. Stotz, archaeologist Eugene M. Gardner, and engineer Edward Stotz to collect background information and field data. Some 400 relics were discovered during their initial investigation. Many of the articles were the first recovered from the French and Indian War period. Today's collection has been called one of the greatest in existence. (Both images courtesy Ligonier Valley Chamber of Commerce.)

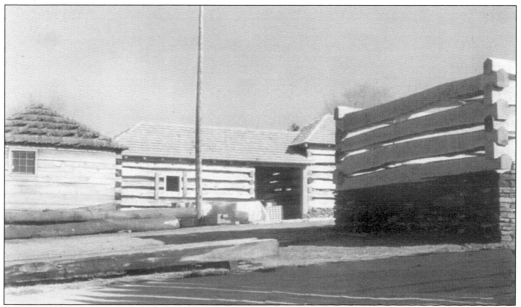

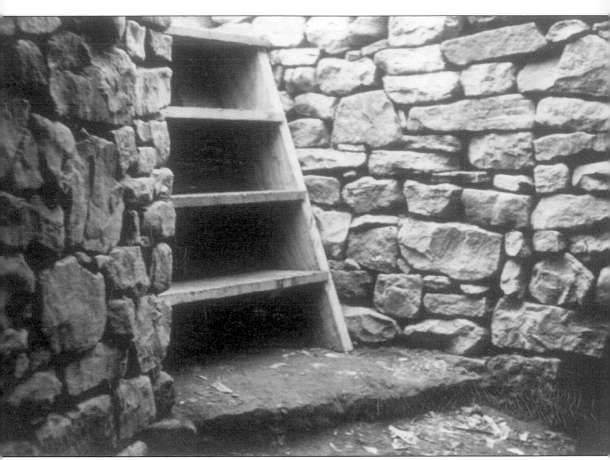

An underground powder magazine was added to the fort following the Forbes campaign. Military engineer Harry Gordon felt that the above-ground magazine posed too great a threat. A single mortar shot could lead to an explosion that would destroy the fort. The old, heavily timbered magazine became a storehouse. (Courtesy Ligonier Valley Chamber of Commerce.)

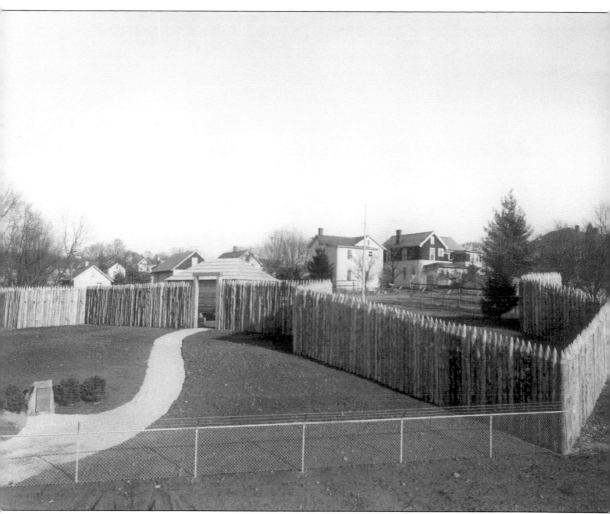

The first phase of reconstruction included the rebuilding of some 400 feet of heavy-pillared stockade wall. Fourteen-foot pickets were sunk side by side about 3.5 feet deep. Gun emplacements were restored at each corner. Inside the fort, the officers quarters were rebuilt. Using 18th-century construction techniques, the first phase took some 3.5 months to complete. Notice the Fort Ligonier marker beside the pathway. It has since been moved, along with the Hermitage marker and the Century Chain, to the front of the museum. (Courtesy Ligonier Valley Chamber of Commerce.)

Authentic to 1758, the King's Colors fly above the fort. The flag features the Cross of St. George of England and the Cross of St. Andrew of Scotland. Later, the Cross of St. Patrick of Ireland was added. The flag flies with the permission of both the American and British governments. (Upper image courtesy Ligonier Valley Chamber of Commerce; lower image courtesy Bruce A. Shirey.)

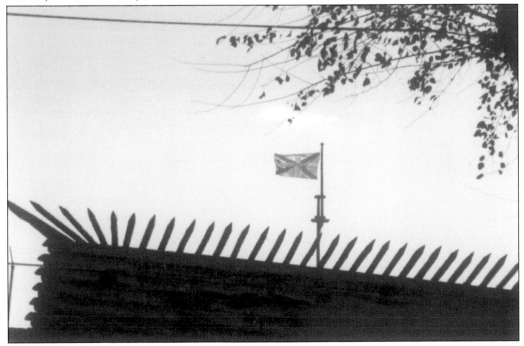

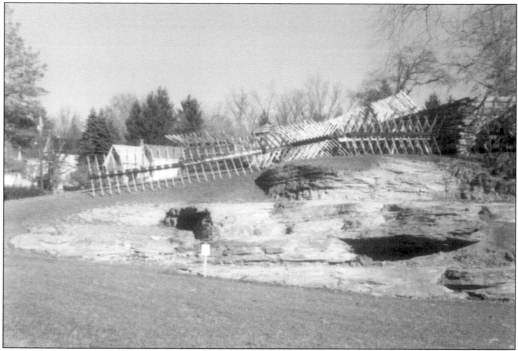

Though the first phase of restoration was completed in 1969, study has continued at the fort and on its grounds over the years. The Project to Complete Fort Ligonier is a three-year effort to re-create the fort to its original dimensions. The features of a fascine gun battery have been located. Other work to be completed as funds allow includes reconstruction of the remaining outer retrenchments and construction of additional buildings. In April 1997, the Pennsylvania Historical and Museum Commission awarded a Keystone Historic Preservation Grant to the fort for the restoration of the 1758–1766 historic landscape at the fort. (Both images courtesy Bruce A. Shirey.)

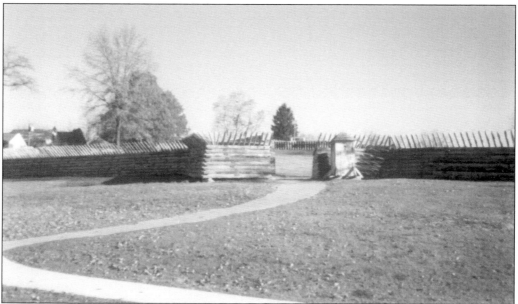

In September 1958, the town celebrated the bicentennial of Fort Ligonier with a week of special events. Mellon Park on West Main Street was dedicated. There was a parade and a special pageant entitled "Westward – An Empire." The President of the United States, Dwight D. Eisenhower, left, spoke on September 26, 1958. He stands here under colonial guard. His speech, broadcast on radio, praised Fort Ligonier as "a significant outpost in frontier history," and he honored those "who kept faith with the spirit of Fort Ligonier and gave us our land, our nation, our freedom." (Courtesy Ligonier Valley Historical Society.)

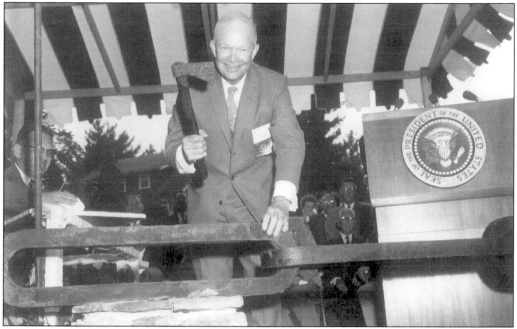

Pres. Dwight D. Eisenhower hand forged the third link in the Century Chain, using an artifact from the fort's collection. The link, cast in nearby Latrobe, contains iron produced at one of the iron furnaces in the valley. (Courtesy Latrobe Foundry Machine & Supply Company.)

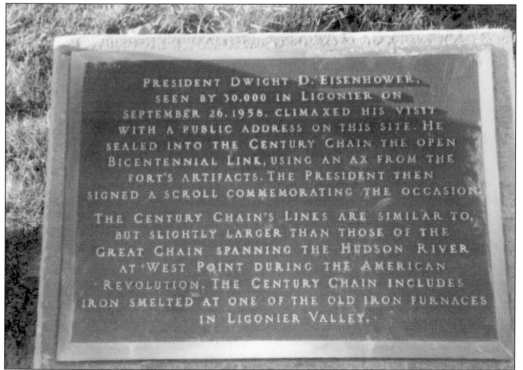

PRESIDENT DWIGHT D. EISENHOWER,
SEEN BY 30,000 IN LIGONIER ON
SEPTEMBER 26, 1958, CLIMAXED HIS VISIT
WITH A PUBLIC ADDRESS ON THIS SITE. HE
SEALED INTO THE CENTURY CHAIN THE OPEN
BICENTENNIAL LINK, USING AN AX FROM THE
FORT'S ARTIFACTS. THE PRESIDENT THEN
SIGNED A SCROLL COMMEMORATING THE OCCASION.

THE CENTURY CHAIN'S LINKS ARE SIMILAR TO,
BUT SLIGHTLY LARGER THAN THOSE OF THE
GREAT CHAIN SPANNING THE HUDSON RIVER
AT WEST POINT DURING THE AMERICAN
REVOLUTION. THE CENTURY CHAIN INCLUDES
IRON SMELTED AT ONE OF THE OLD IRON FURNACES
IN LIGONIER VALLEY.

This plaque, noting the presidential visit, sits outside the Fort Ligonier Museum with the Century Chain and the Fort and Hermitage markers. (Courtesy Bruce A. Shirey.)

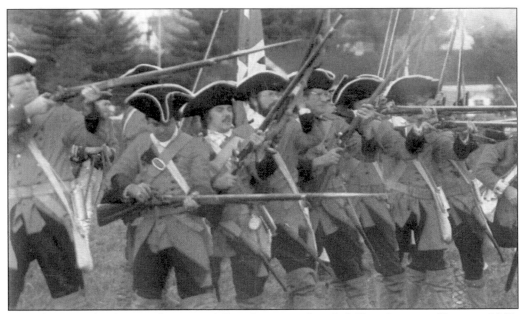

Malcolm Tweedy, former director of Fort Ligonier, founded Fort Ligonier Days in 1960, hoping to keep the spirit of the bicentennial activities alive. Fort Ligonier Days is a three-day celebration of the important role Fort Ligonier played in the development of the country. It is commemorated annually on the weekend nearest October 12. The festivities include musical entertainment, a community parade, crafts, and food. A highlight of the weekend is the reenactment of the October 12, 1758 battle at the fort. (Upper image courtesy Doris Matthews; lower image courtesy Ligonier Valley Chamber of Commerce.)

Two

LIGONIER BOROUGH

The Ligonier Valley was the first stopping place west of the Alleghenies for those headed to new lives in the West. As was the case throughout the area, settlements and towns grew up near fortified locations. The Philadelphia–Pittsburgh Turnpike brought a much-needed sense of permanency to the area when it was completed in 1817 and greatly influenced the development of the Ligonier Valley. It was the first dependable, hard-surfaced road in the area. As travel along the turnpike increased, innkeeping became another early industry in the valley. Through 1850, most of the growth in Ligonier occurred along Main Street—the turnpike corridor.

--Though the story of Ligonier Borough seems to begin with the construction of the Philadelphia–Pittsburgh Turnpike, it actually starts with a sheriff's sale in 1794. Gen. James Ramsey (sometimes spelled Ramsay) of Franklin County bought what was known as the Ligonier Tract, some 672 acres. He later conveyed the land to his son John, who laid out the town of Ligonier.

When the initial offering was made public, the town was named Ramseytown, but this ignited some outrage among the residents. The name was first changed to Wellington (after the man who defeated Napoleon Bonaparte at Waterloo) before the name Ligonier finally stuck.

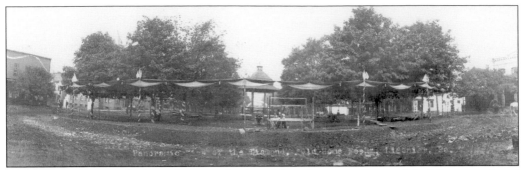

When John Ramsey laid out Ligonier, he based his plan on a diamond (public square) and grid pattern. It consisted of about four blocks. The town square became the hub of social and business activity. This 1908 photograph shows the Ligonier Diamond all decked out for the Sesquicentennial Celebration and Old Home Week. The view is from East Main Street looking west. (Courtesy Ligonier Valley Historical Society.)

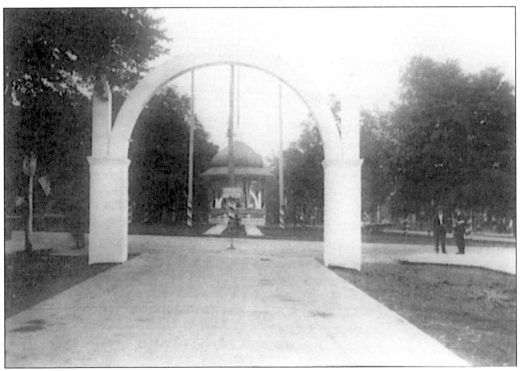

The Lincoln Highway was the first improved road to stretch across the country. It was started in 1913 and, by 1925, most of the original portion had become U.S. Route 30. The paved highway arrived in Ligonier in 1919. The Lincoln Highway followed the path of several earlier roads. In Ligonier it traced the route of the old Philadelphia–Pittsburgh Turnpike down Main Street. (Courtesy Ligonier Valley Chamber of Commerce.)

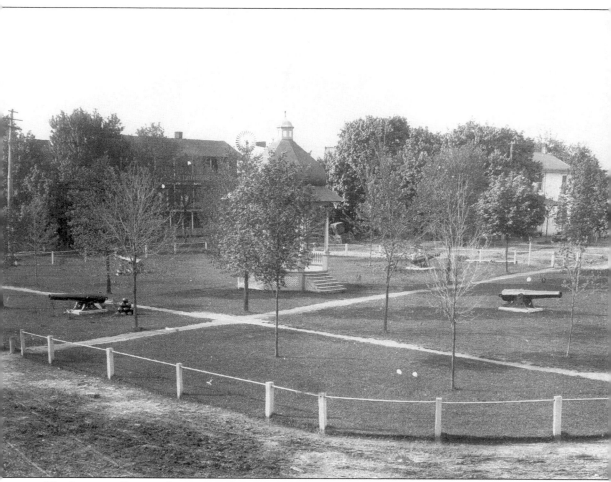

The Ligonier Diamond, now purely ornamental, was at first utilitarian. Coaches and wagons could park for the night, and a corral with hitching posts held livestock. Congressman Huff donated the Civil War cannons pictured here to the Ligonier Grand Army of the Republic (GAR) post. The guns remained in position until World War II, when they were donated to the war scrap effort. To the back left of the bandstand is the Ligonier House. Notice the pipe fence designed to keep buggies out of the town square. (Courtesy Ligonier Valley Historical Society.)

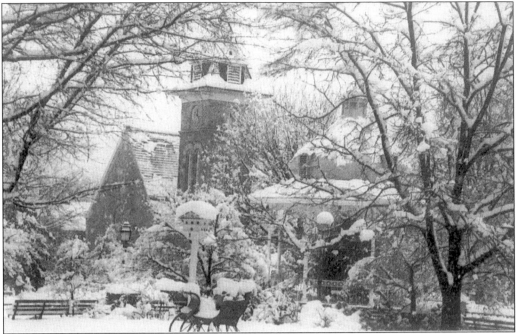

This postcard bears the inscription "Winter Wonderland on the Ligonier Diamond, Ligonier Pennsylvania." It shows Heritage United Methodist Church in the background and the town square decorated for the holidays. (Photograph by Beth Caldwell; courtesy Doris Matthews.)

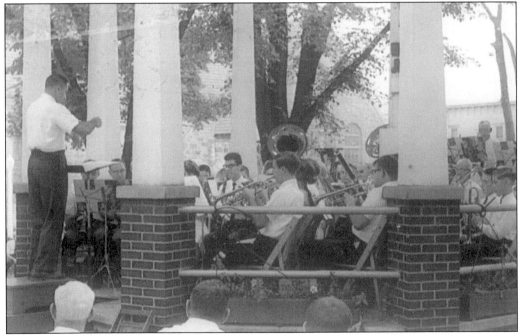

Sunday evening concerts on the Ligonier Diamond have been a summer tradition for more than 50 years. Concert-goers bring blankets and chairs and make it an evening, enjoying the music and the company. Concerts begin the weekend of Memorial Day and run through the end of August. (Courtesy Ligonier Valley Chamber of Commerce.)

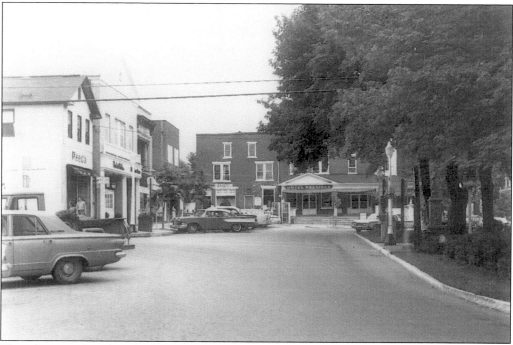

This photograph, taken looking east to the Breniser Hotel, shows the northeast corner of the Ligonier Diamond. (Courtesy Ligonier Valley Historical Society.)

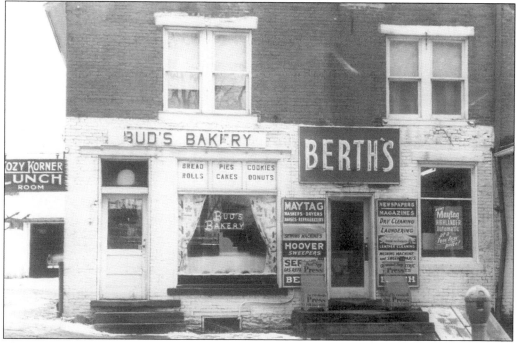

This brick house was built c. 1818. It housed Breniser and Smith, general merchandisers. The building was moved back to this location in 1900 and became a wing of the new Breniser Hotel. Bud's Bakery opened in 1949 and moved to Ligonier in 1950. (Courtesy Ligonier Valley Chamber of Commerce.)

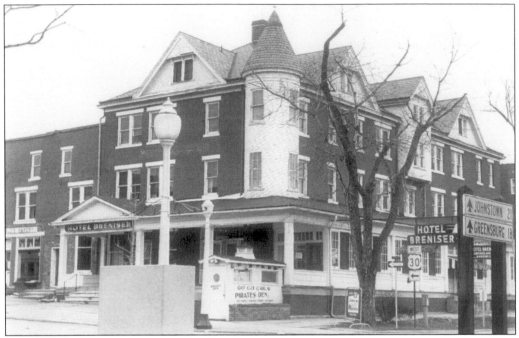

When it was being built in 1900 by Pete Breniser, the Breniser Hotel was touted as being one of the finest and most modern hotels in town. By the mid-1960s, having changed hands several times, the hotel had seen better days. It was slated for demolition to make room for a new community building. (Courtesy Ligonier Valley Chamber of Commerce.)

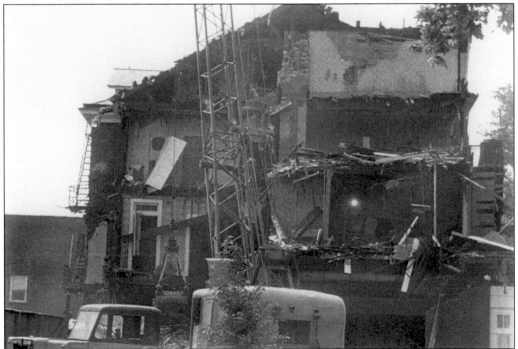

In 1967, Noralco Corporation of Pittsburgh took down the Breniser Hotel. (Courtesy Ligonier Valley Chamber of Commerce.)

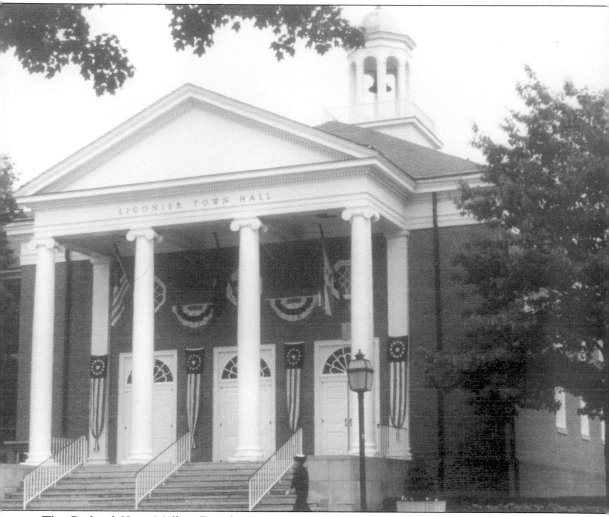

The Richard King Mellon Foundation gave a grant to Ligonier for the construction and equipping of a new community building on the northeast corner of the Ligonier Diamond. The Ligonier Town Hall, a Georgian brick building with a four-column portico, houses a 320-seat auditorium and offices for the school district, Ligonier Valley Chamber of Commerce, and various other borough and civic groups. A large room in the basement serves as a community room. The belfry contains the bell from the old Dickinson School. A postcard of the Dickinson School appears on page 72. (Courtesy Ligonier Valley Chamber of Commerce.)

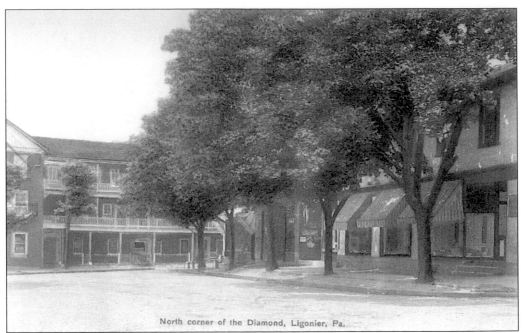

North corner of the Diamond, Ligonier, Pa.

Here begins a series of four images of the same block. This postcard, dated 1916, shows the northwest corner of the Ligonier Diamond, with the Ligonier House in the background. (Courtesy Ray Kinsey.)

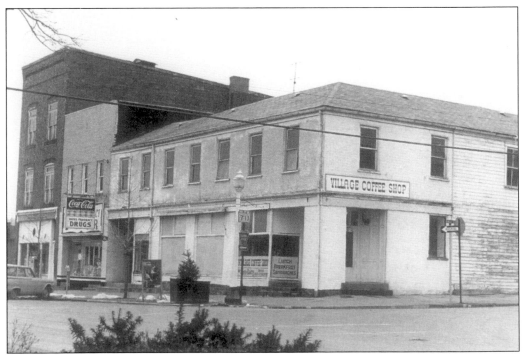

This view features Hayes Pharmacy and the Village Coffee Shop. (Courtesy Ligonier Valley Chamber of Commerce.)

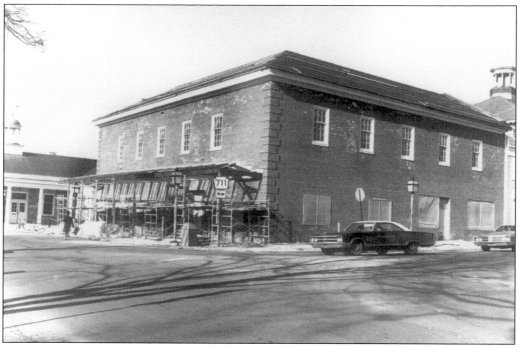

The new building on the corner of the Ligonier Diamond and North Market Street is nearly completed. (Courtesy Ligonier Valley Chamber of Commerce.)

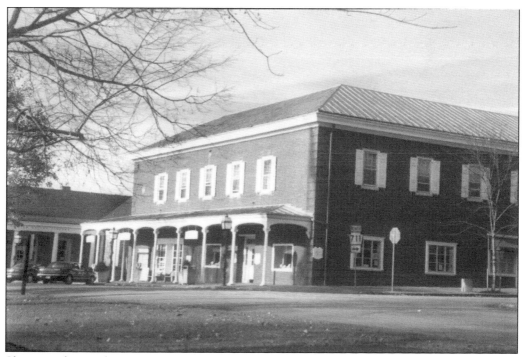

Shown is the northwest corner of the Ligonier Diamond today. (Courtesy Bruce A. Shirey.)

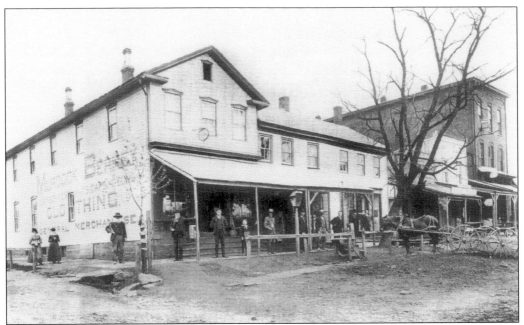

This is the first of a series of four views of the northeast section of the Ligonier Diamond. Murdock Brothers bought this corner in 1870 and Murdock and Berkey formed their partnership in 1879. They removed an old hotel and built their storeroom. Notice the horse and buggy and the steps for help mounting and dismounting in front of the store. (Courtesy Martin's Specialty Shop.)

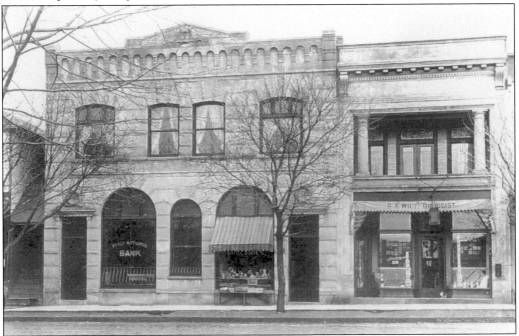

This undated postcard indicates that you could open an account at the First National Bank for just $1. The bank sat on the northeast corner of the Ligonier Diamond, next door to the Murdock and Berkey store. (Courtesy Ligonier Valley Historical Society.)

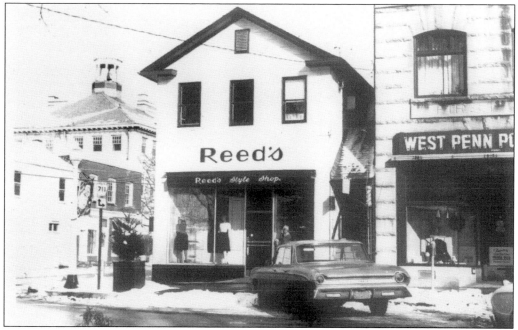

This view shows the northeast corner of the Ligonier Diamond before the 1967–1968 reconstruction. The Reed's building was more than 100 years old when it was torn down. It was used over the years as a restaurant, beauty shop, and various stores. Note that West Penn Power was now occupying the First National Bank building. (Courtesy Ligonier Valley Chamber of Commerce.)

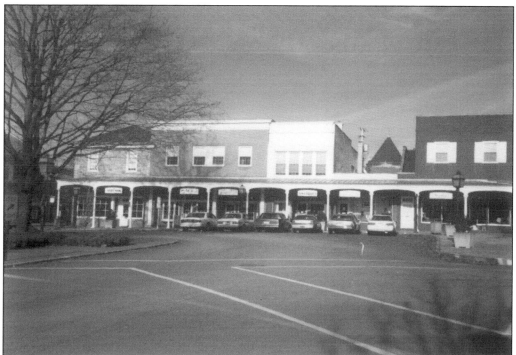

Shown is the northeast corner of the Ligonier Diamond today. (Courtesy Bruce A. Shirey.)

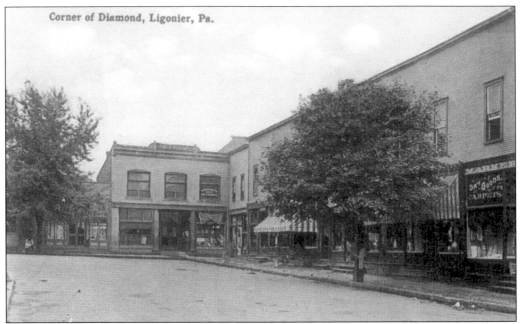

This undated postcard shows the southeast corner of the Ligonier Diamond, with the Deeds and Marker buildings. It begins a series of five images. (Courtesy Ray Kinsey.)

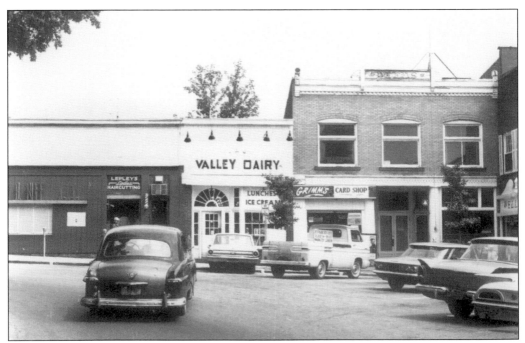

Many Ligonier students stopped at the Valley Dairy for a treat after the school day was over. This corner was sold in 1974 and demolished. A new brick building stands in its place. A glimpse of the new building can be seen in the photograph on page 2. (Courtesy Ligonier Valley Chamber of Commerce.)

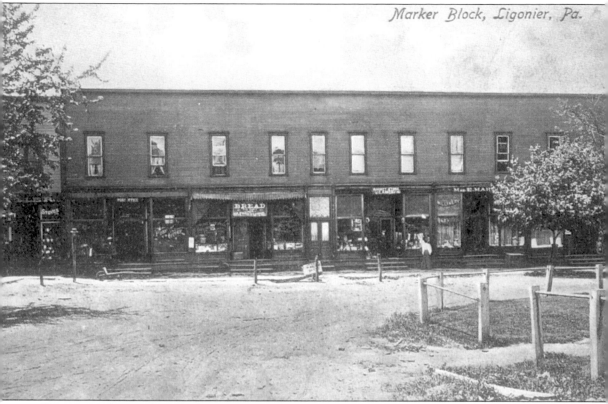

Marker Block, Ligonier, Pa.

Tenants in the Marker Block included, from left to right, Weller Hardware, which had been in business since 1888; the post office; a grocery store; B.I. Mathews's 5 & 10; a milliner; and Marker's general store. (Courtesy Doris Matthews.)

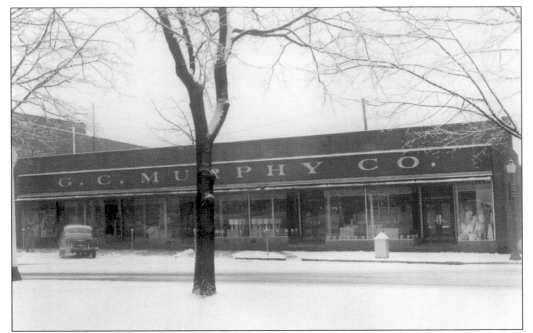

The G.C. Murphy Company began serving Ligonier in 1927. In August 1950, the newly rebuilt and remodeled store had its grand reopening. (Courtesy Ligonier Valley Chamber of Commerce.)

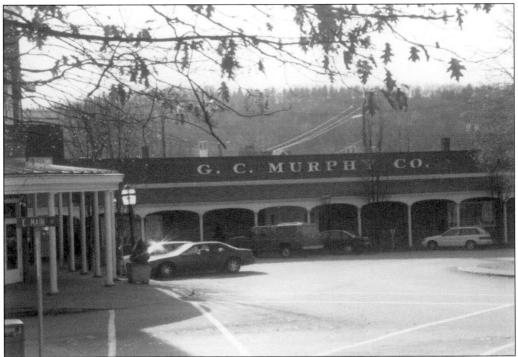

The store was remodeled and enlarged again in 1974. Officials from both the store and the town took part in a ribbon-cutting ceremony. This photograph was taken in the fall of 2000. (Courtesy Bruce A. Shirey.)

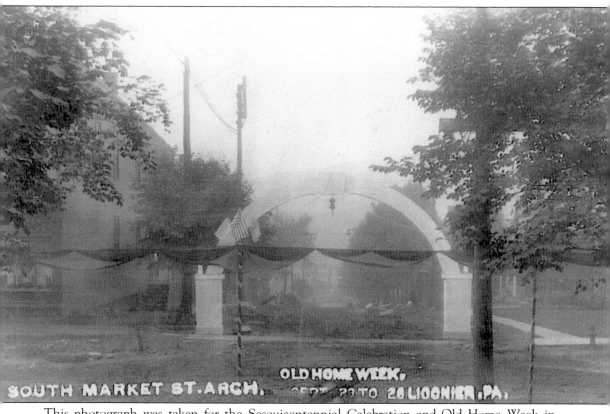

SOUTH MARKET ST. ARCH. OLD HOME WEEK, SEPT 23 TO 26 LIGONIER, PA,

This photograph was taken for the Sesquicentennial Celebration and Old Home Week in 1908. The Ligonier Diamond has its bunting and flags. The view is looking south toward the Loyalhanna Creek. Market Street is torn up, as it was about to become the first paved street in town. It joined the paved sections of the state road that came from Oak Grove to Ligonier and from Ligonier up Hargnett Hill. The porch of the old Heritage Church parsonage is just visible on the right. (Courtesy Ray Kinsey.)

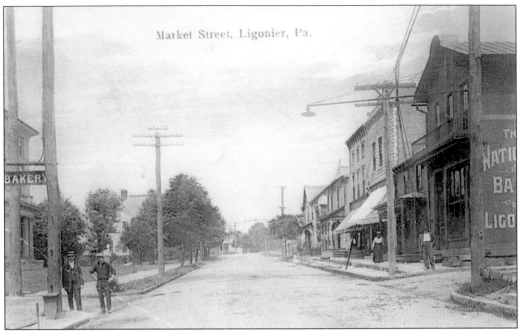

Market Street, Ligonier, Pa.

This postcard is postmarked July 12, 1911. The public school at the left (behind the bakery sign) is now the municipal parking lot. (Courtesy Doris Matthews.)

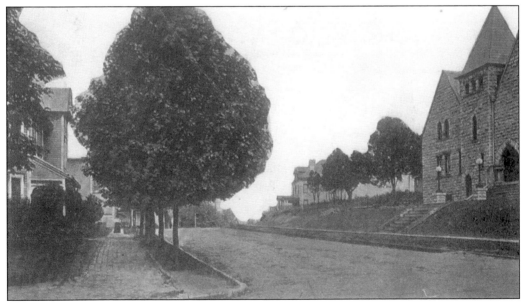

This postcard view of North Market Street is postmarked September 16, 1914. It shows Covenant Presbyterian Church on the right. (Courtesy Doris Matthews.)

In the cemetery beside Covenant Presbyterian Church are markers for many of the early settlers of Ligonier, including James and Mary Burd and Louisa St. Clair Robb. James Burd arrived with the forces of Gen. John Forbes. Louisa St. Clair Robb is a daughter of Arthur St. Clair. (Both images courtesy Bruce A. Shirey.)

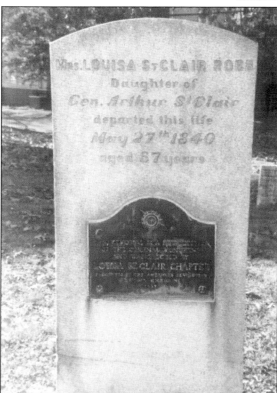

When the Ligonier Diamond area underwent its renewal in the mid-1960s, many other shops in town also did some renovating. The Hair Fashion Center is located just off the square on North Market Street. (Both images courtesy Ligonier Valley Chamber of Commerce.)

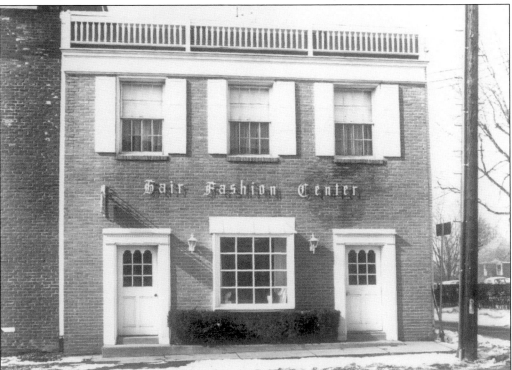

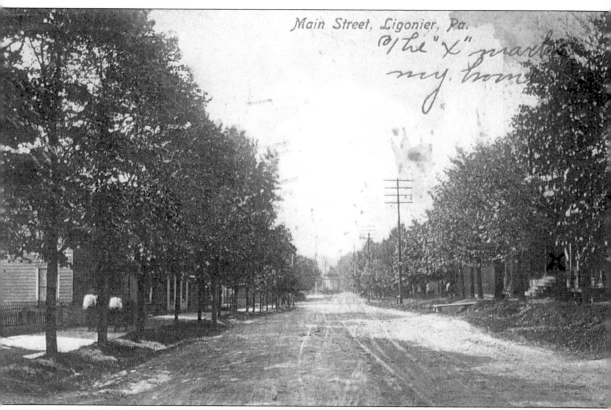

Main Street, Ligonier, Pa.

the "X" mark my home

Postmarked July 2, 1908, this view of East Main Street looks west toward the Ligonier Diamond. Notice the buggy tracks in the unpaved road. Today, many of the houses along this street contain shops. (Courtesy Doris Matthews.)

Over the years, several establishments have had their home at 141–143 East Main Street. (Both images courtesy Ligonier Valley Chamber of Commerce.)

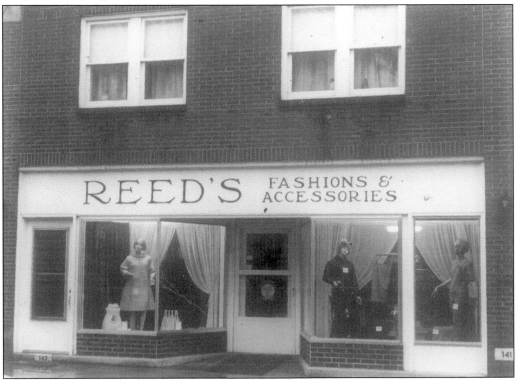

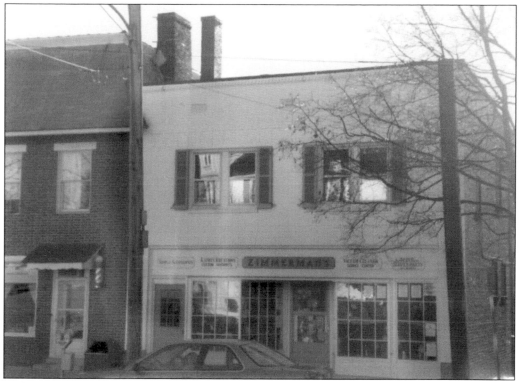

Today, this building houses yet another retail establishment. It sits next to the old National Hotel, home to the Veterans of Foreign Wars. (Both images courtesy Bruce A. Shirey.)

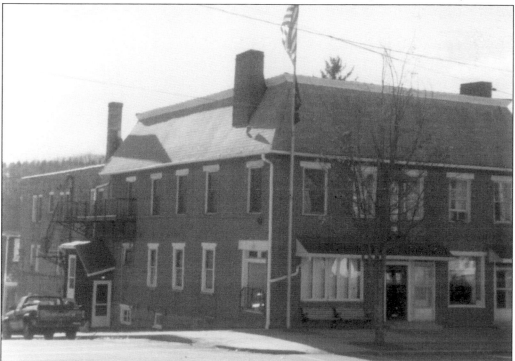

This postcard, postmarked June 8, 1935, shows the South Market Street Bridge across the Loyalhanna Creek before Route 30 was improved. (Courtesy Doris Matthews.)

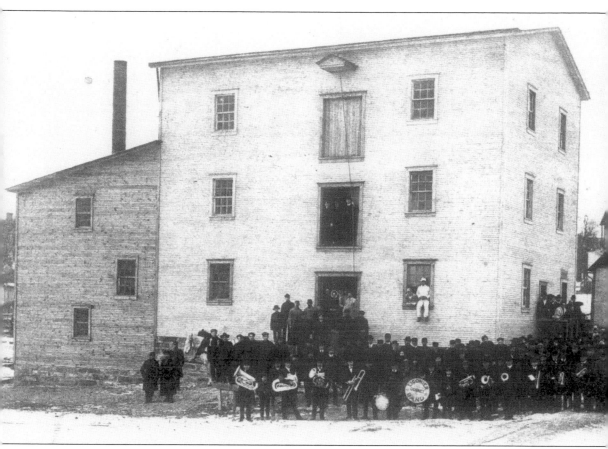

Farmers brought their corn, wheat, rye, and buckwheat for grinding to a mill, such as Triece's Ligonier Roller Mill on South Market Street. The millers charged their customers a small fee and a portion of the flour and meal as payment. There were several mills such as this in the valley. Triece's makes an interesting backdrop for the Ligonier Cornet Band, though the occasion is not known. (Courtesy Martin's Specialty Shop.)

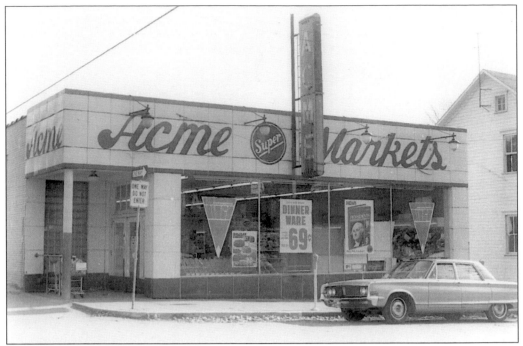

In 1967, continuing the townwide renovation effort, bids were awarded to build a new Acme Market to replace this one on South Fairfield Street. This is the first of a four-image series. (Courtesy Ligonier Valley Chamber of Commerce.)

These old houses were torn down to make room for the new Acme store. (Courtesy Ligonier Valley Chamber of Commerce.)

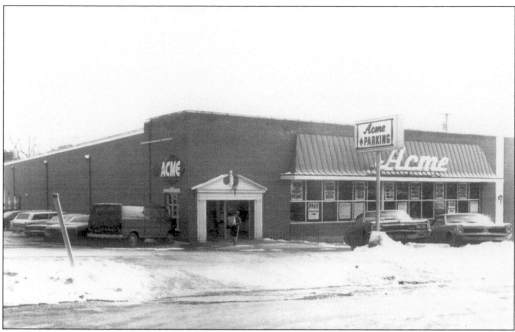

This is the new Acme store. (Courtesy Ligonier Valley Chamber of Commerce.)

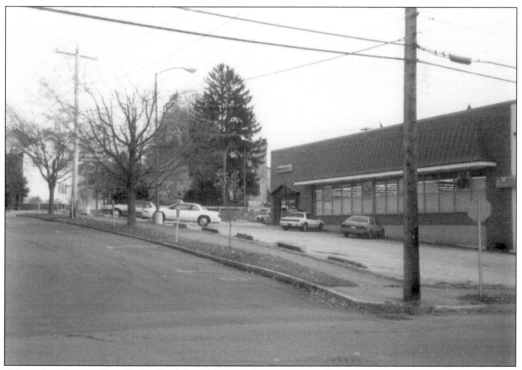

After the Acme closed, the building became home to another grocery store and then to some small retail shops. Today, it houses a chain discount store. (Courtesy Bruce A. Shirey.)

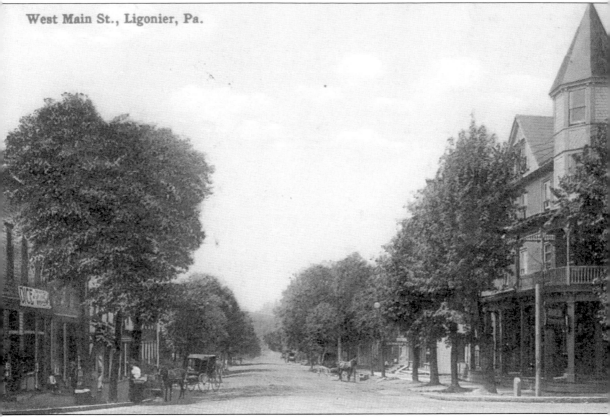

The Frank Building, left, was built in the 1860s. Benn Kline bought the building in 1915. The Kline family ran a store here for years. Sam Dice had his barbershop in the west end of this building. The Ligonier House is on the right. This is a view looking west from the Ligonier Diamond. (Courtesy Doris Matthews.)

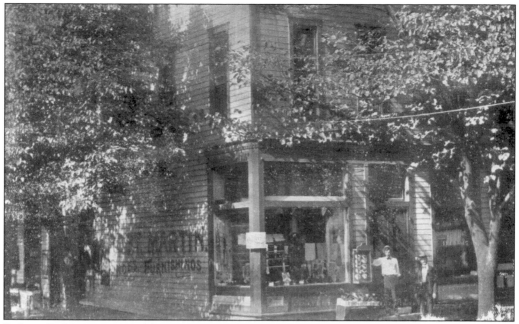

Robert S. Martin opened his store on February 1, 1900, in the Frank Building. When the building was sold to Benn Kline, Martin moved his store across the square to its present location near the town hall. Martin's son and granddaughter have followed in the family business. (Courtesy Martin's Specialty Shop.)

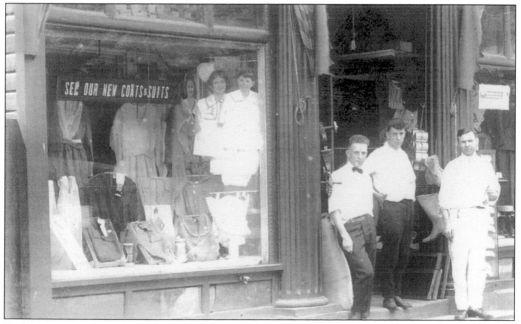

Built by L.A. Weaver in 1880, this was the second building to house Weaver's store. L.A. Weaver often traded his merchandise with farmers and trappers for their goods. This c. 1915 photograph shows John Felgar, an unidentified gentleman, and Byron Weaver in front of the store, which later housed other retail establishments. (Courtesy Ligonier Valley Historical Society.)

The "tonsorial parlor" on West Main Street (upper image) is still a barbershop today. Reflected in its window is the building across the street (lower image). The library was located on the east end of this building in 1945. It was used variously as a tourist home, beauty shop, and barbershop. (Upper image courtesy Ligonier Valley Historical Society; lower image courtesy Ligonier Valley Chamber of Commerce.)

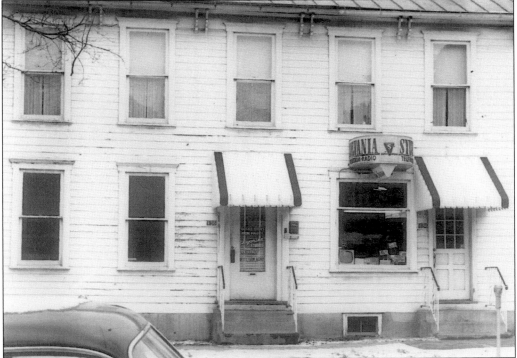

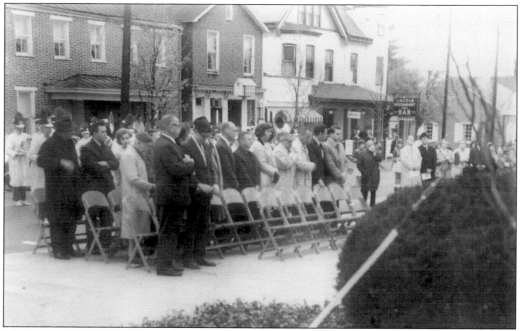

This photograph from October 1966 shows the dedication of the new post office. In the background is the block containing the barbershop shown on the previous page. (Courtesy Ligonier Valley Chamber of Commerce.)

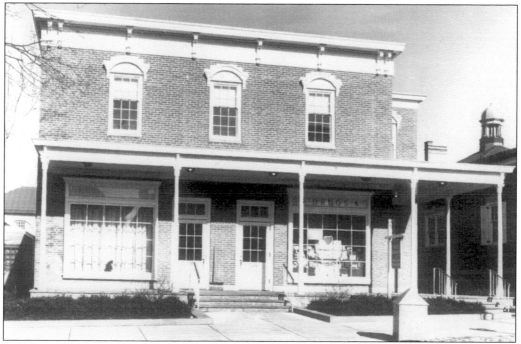

This brick building stands on the site of the frame building shown on the previous page. It was one of the earliest to set the style for the town's redevelopment. It has two shops with basement storage on the first floor. The second floor has office space. (Courtesy Ligonier Valley Chamber of Commerce.)

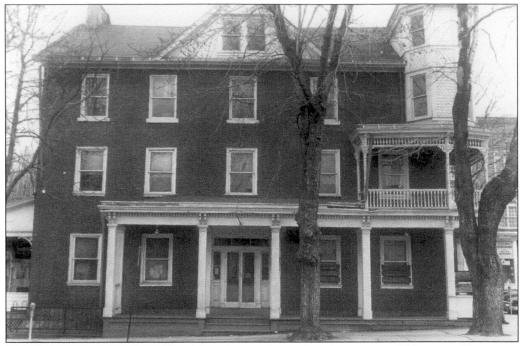

The above view, taken from West Main Street, shows that the century-old Ligonier House was past its prime by the 1960s. The view below, taken from the same elevation, shows the library today. (Upper image courtesy Ligonier Valley Chamber of Commerce; lower image courtesy Bruce A. Shirey.)

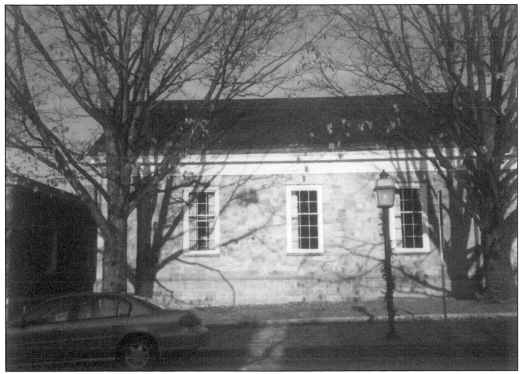

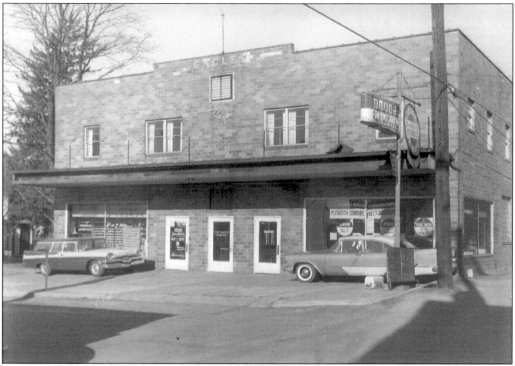

Both of these garages, the one on South Fairfield Street, above, and the one on North St. Clair Street, below, are still in existence today, though neither is still a car dealership. (Courtesy Ligonier Valley Chamber of Commerce.)

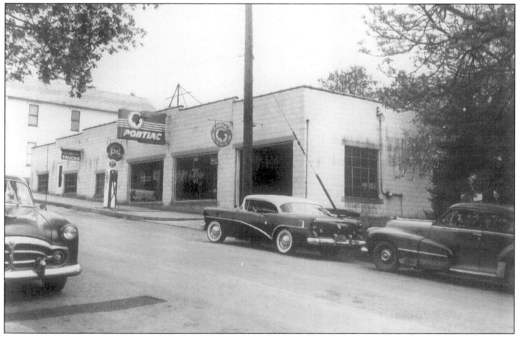

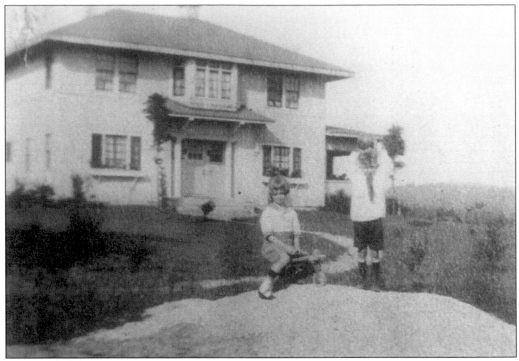

These unidentified children pose outside the McElroy home on Bell and Church Streets. The house later became a funeral parlor. (Courtesy Ligonier Valley Chamber of Commerce.)

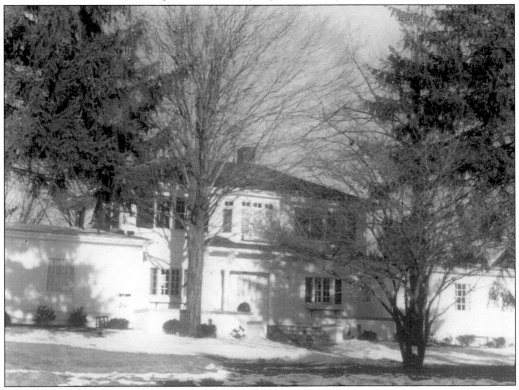

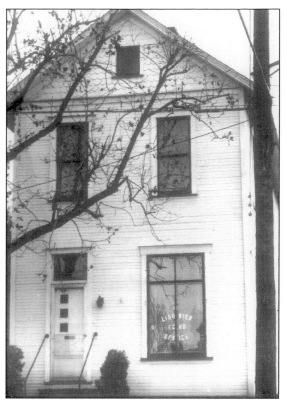

Four newspapers preceded the *Ligonier Echo,* which debuted on September 5, 1888. Prof. I.M. Graham joined the *Echo* in 1890 and became the full owner and editor. Three generations of the Graham family led the paper for 68 years. Today, the paper is owned by the Laurel Group and is published weekly. This building on St. Clair Street was built following the fire that destroyed the Marker Block in 1896. It served as the publication office and print shop until it was sold in 1958. (Upper image courtesy Ligonier Valley Historical Society; lower image courtesy Bruce A. Shirey.)

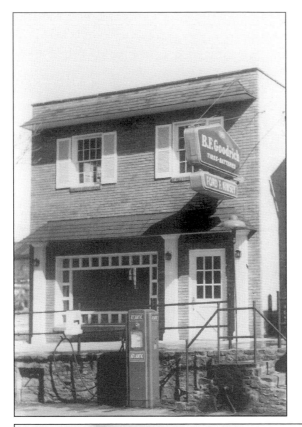

Kinsey's Garage on East Main Street has been a staple in town for many years. It, too, was caught up in the colonial redevelopment. Today, the gas pump is gone, but the millstones remain in place. (Upper image courtesy of Ligonier Valley Chamber of Commerce; lower image courtesy Bruce A. Shirey.)

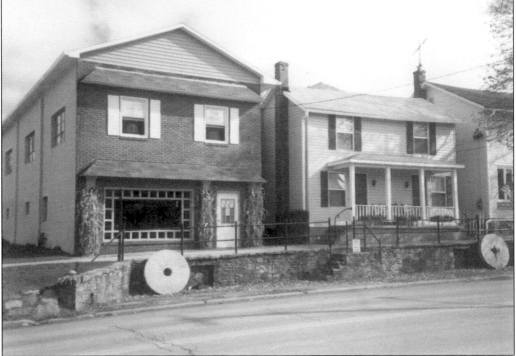

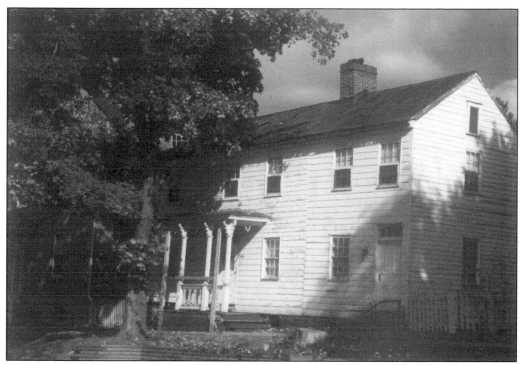

This house on East Main Street is believed to be one of the oldest standing in Ligonier. The addition to the right indicates that it was used as a shop as well as a home. With its zero setback in front, the backyard had plenty of room for a cook house, barn, gardens, and so on. (Courtesy Bruce A. Shirey.)

This marker welcomed travelers from the east on the Lincoln Highway to Ligonier. One of a pair, it is missing the lamp that once sat on top. Also missing today is its twin marker. (Courtesy Bruce A. Shirey.)

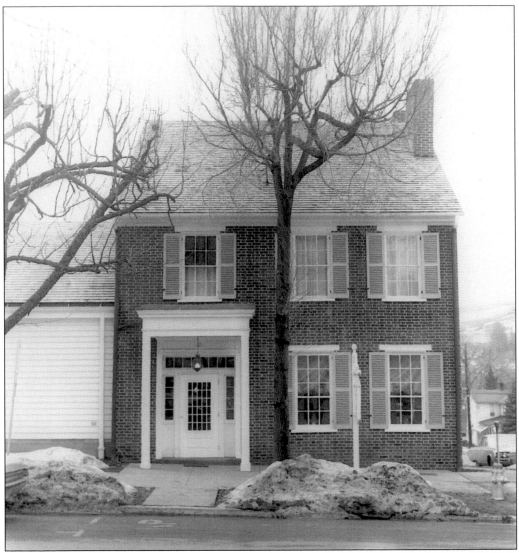

Noah M. Marker was a prominent civic leader, legislator, and businessman in Ligonier. He built the brick Ivy Manor c. 1850. Dr. McAdoo, one of Ligonier's early physicians, used Ivy Manor as his home and office. Later owners developed the building into other facilities, including restaurants and shops. Today, the building houses several retail establishments. (Courtesy Ligonier Valley Historical Society.)

Three

PUBLIC SERVICE

When John Ramsey laid out the town of Ligonier in 1817, there were few families in the valley. Individuals took care of their own needs, though Ramsey allowed for the development of areas for churches and schools in his town plan. As the population grew, so did the necessity for various forms of public service organizations.

In addition to basic fire and police protection, many other groups serve the people of Ligonier Valley. Public and private schools educate its citizens, and higher education is available within a very short distance. The local library is linked with libraries throughout the county and offers a remarkable range of services.

There are nearly 20 churches of different denominations in the valley. Civic and fraternal organizations abound, and various welfare agencies help meet the needs of valley residents. There are personal care homes and assisted living facilities, municipal boards, and authorities.

Theatre and musical groups enhance the cultural life of Ligonier. There are various festivals and festivities throughout the year, throughout the valley. These range from the Flax Scutching Festival, Fort Ligonier Days, and the Country Market to the many annual events on the Ligonier Diamond.

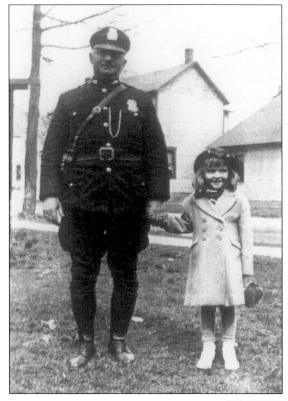

Police Chief Charles "Chud" Wilt gave his life in service to his community. A 25-year veteran of the police force, he suffered a heart attack in 1941 while helping fight the fire that started in Nicely's Livery Stable. The fire spread to several nearby buildings on the north side of the square. (Courtesy Ligonier Borough Police Department.)

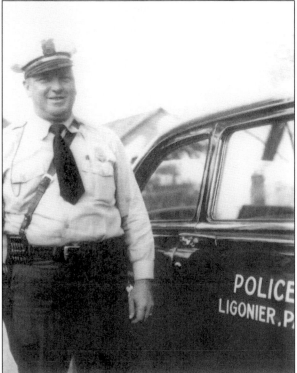

Chief Joseph Gardner stands beside the borough's first police car. (Courtesy Ligonier Borough Police Department.)

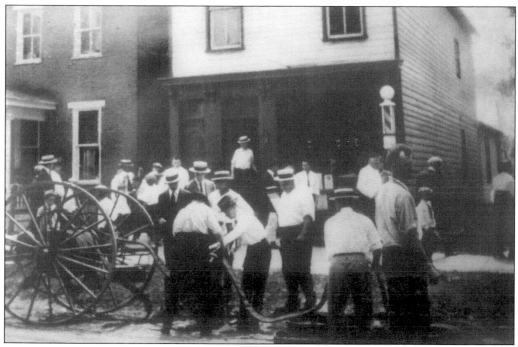

The fire department was organized in 1897. This photograph, taken c. 1918, shows the department in action in the first block of West Main Street. Note the unusual firefighting clothing—white shirt, tie, straw hat. This is the same tonsorial parlor that appears on page 54. The name Dice can barely be seen in the window. (Courtesy Ken Knupp.)

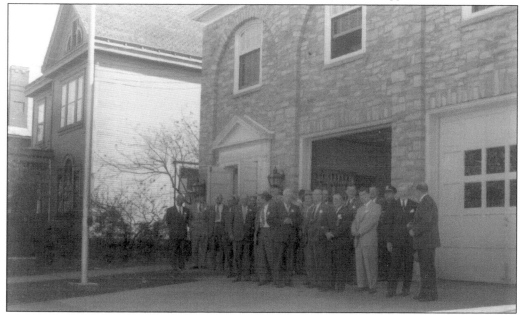

The fire station was built as a project of the Works Progress Administration. The WPA sought to ease the effects of the Great Depression. The building has a random stone veneer and a hip roof. Here, a group of visiting businessmen pose for a picture. (Courtesy Ligonier Valley Chamber of Commerce.)

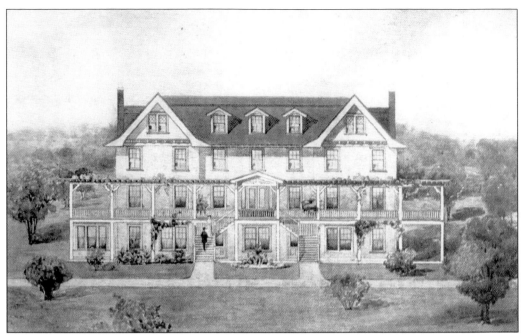

In 1906, the Ligonier Park Cottage was built on the land of George W. Deeds. This postcard, postmarked August 1911, captures the beauty of this large hotel. Despite its splendid view and fine food and accommodations, the resort never caught on with the summer tourist crowd. During the flu epidemic of 1918, it was converted into a hospital. (Courtesy Doris Matthews.)

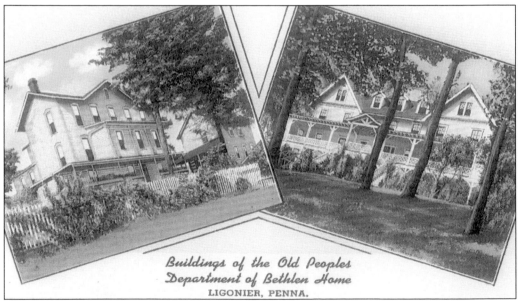

In 1921, the Ligonier Park Cottage became a charitable home for orphans, dependents, and the elderly. The Bethlen Home was established in 1921 by the Hungarian Reformed Federation of America. It was named for Gabriel Bethlen, a prince from Hungary who had been an orphan. (Courtesy Doris Matthews.)

The Bethlen Home was formally
dedicated on July 4, 1924, its third
anniversary. These are views of the
grounds today. (Courtesy Bethlen Home.)

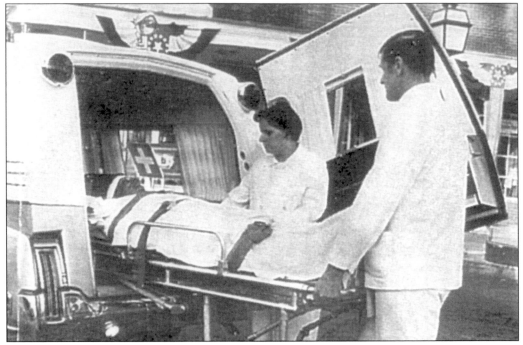

At one time, area funeral directors provided the emergency transportation in the valley. There was not an official ambulance service until 1967, when the Ligonier Valley Ambulance Service was founded with a gift from the R.K. Mellon Foundation. The photograph above shows the first ambulance in the service. Today the service operates under the direction of Latrobe Area Hospital, providing paramedics and emergency medical technicians on all trips. Nonemergency and nonmedically necessary transportation is also available. The photograph below shows the 1987 ambulance. (Courtesy Ligonier Valley Ambulance Service.)

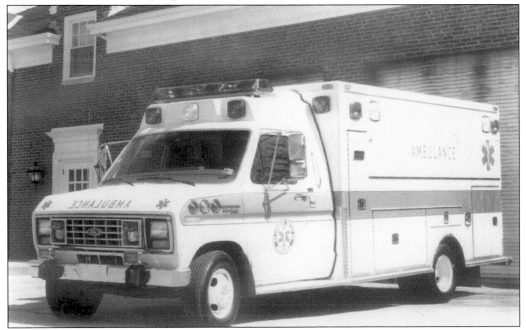

McGinnis Hospital was opened on February 28, 1948, by Helen Newlin McGinnis. It had 17 beds and 6 bassinets and offered full maternity, X-ray, and lab facilities, a blood bank, and some surgery. In the 1920s, the facility had been the home of Jack Voegle. It continues as a medical facility today. (Upper image courtesy Ligonier Valley Historical Society; lower image courtesy Bruce A. Shirey.)

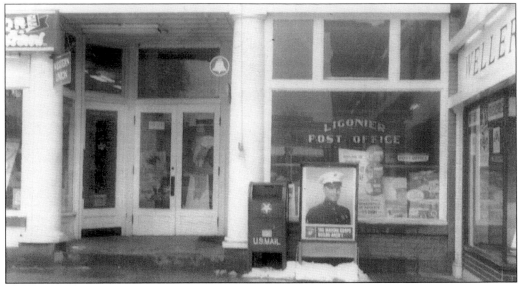

This location on the Ligonier Diamond served as the post office from 1925 until 1966. By the time it closed, the mere 2,000 square feet of space limited the facility and made the building obsolete. There was no room for the more modern postal equipment of the day. (Courtesy Ligonier Valley Chamber of Commerce.)

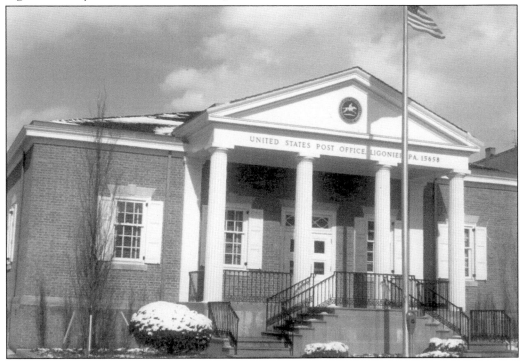

Groundbreaking for a new post office took place in 1966 on the site of the old Valley Restaurant and a portion of the Ligonier Hotel property. More than double the size of the old post office, the new one also had a proper loading dock. It was dedicated on October 29, 1966. The photograph on page 55 shows the dedication ceremony. (Courtesy of Ligonier Valley Chamber of Commerce.)

In 1884, a small group of Ligonier citizens met to start a library; in 1886, the group was given a room on the public school grounds. In 1925, the Ligonier Pharmacy was offering a circulating library for the cost of 3¢ per day. In 1945, the Ligonier Woman's Club took on the project of reestablishing the Ligonier Valley Library. From its start at 134 West Main Street, the library moved to 223 East Main Street and then to its present location on the square in 1968. In addition to books, the library offers special programs for adults and children including book discussions, lectures, demonstrations, and art shows. The Pennsylvania Room offers a fine collection of history and genealogy from Pennsylvania and Westmoreland County in particular. A new addition to house its ever-expanding collection of materials was completed in 2001. (Courtesy Ligonier Valley Chamber of Commerce.)

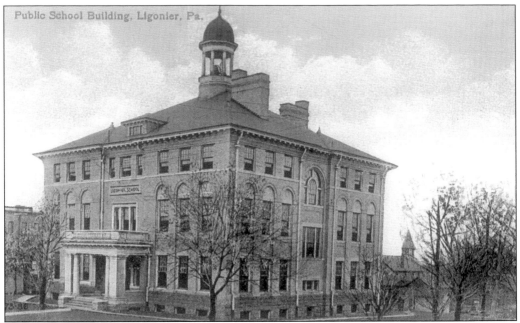

Traditionally, the first public school in Ligonier Borough was located on Church Street between the Methodist and Presbyterian churches. The second public school was a red-brick, two-room school, which was quickly outgrown. The Dickinson School, shown here, was built in 1903. Today, this site is a municipal parking lot. (Courtesy Ray Kinsey.)

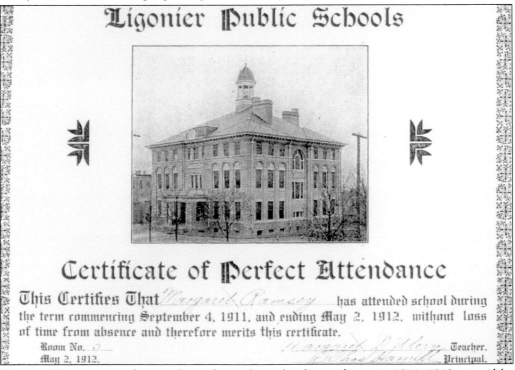

Margaret Ramsey earned a certificate for perfect school attendance in 1911–1912, signed by Margaret Ulery, teacher, and F. Thomas Hamilton, principal. (Courtesy Bob Ramsey.)

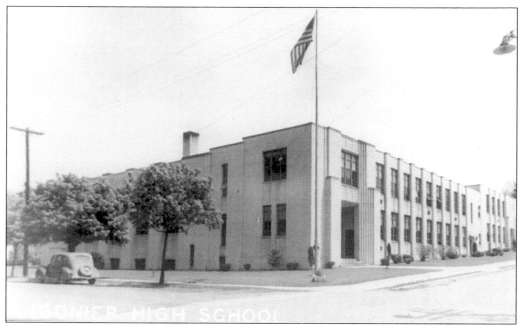

Ground was broken for a new high school in 1923. The first section (the near, west end) opened in 1932 with six classrooms and an auditorium. In 1936, a gymnasium and eight additional classrooms were added. Various groups, including the Valley Players, a local theater company, used the school auditorium until 1967, when the Ligonier Town Hall became available. (Courtesy Ray Kinsey.)

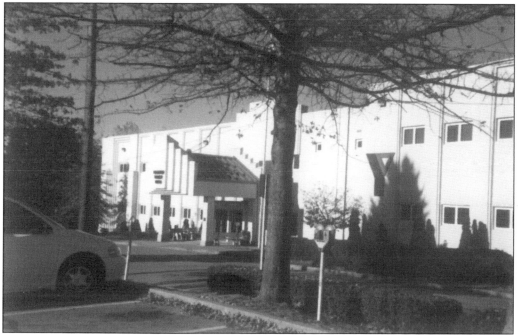

The old high school continues to serve the community today as the home for the YMCA. In 1982, today's YMCA grew out of the Community Center of Ligonier Valley. The Y has a wide range of facilities and activities available for the whole family. (Courtesy Bruce A. Shirey.)

The first Lutheran services were held in the valley as early as 1790. In 1851, the congregation took on the name St. James and dedicated its church on West Main Street. A parsonage was built in 1882. The present church, which utilizes part of the original church walls, was built in 1898. The old parsonage was torn down and replaced with a new one in 1958. (Courtesy Doris Matthews.)

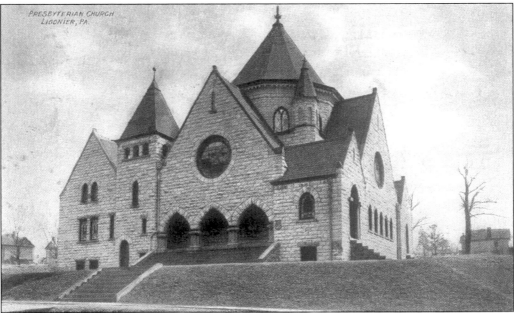

Covenant Presbyterian Church began in 1817 as part of the Pleasant Grove and Fairfield charges. The first church, a small brick building, was built in 1820, followed by a larger facility in 1847. The cornerstone for the present church was laid in 1902. The church was constructed of sandstone from the McCance quarries. It was dedicated in 1904. The educational wing was added in 1958. (Courtesy Doris Matthews.)

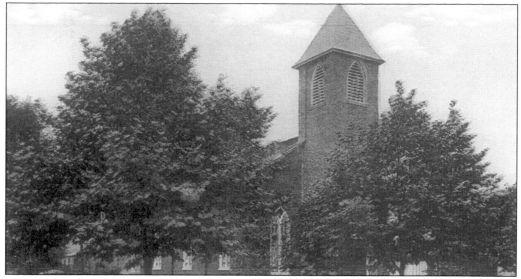

Holy Trinity Parish began as an outreach of an order of priests from York. Later, the parish came under the care of Boniface Wimmer of St. Vincent Archabbey in Latrobe. The brick church building was erected in 1854, and the stained-glass windows were added in 1907. In 1957, to accommodate its growing parish, Holy Trinity bought the engine house and 6.5 adjacent acres from the defunct Ligonier Valley Rail Road. The engine house was converted to a church and social hall, and the parish school opened in the renovated roundhouse. The first church services were held in the new building in 1958. (Courtesy Doris Matthews.)

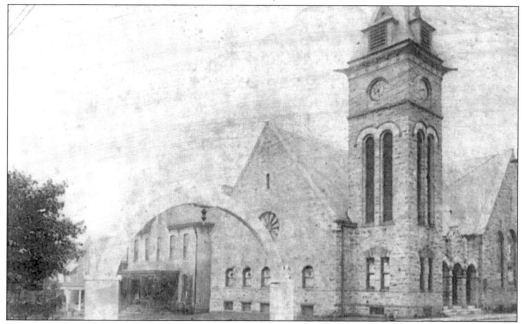

Heritage United Methodist Church was established in 1784 by a letter from John Wesley. As was the case with many area churches, the first services were held in the homes of parishioners, including that of Jacob Shaw. The first church was a frame structure, built in 1829, located at Church and St. Clair Streets. This view shows the present church and its parsonage, which was demolished to make way for an educational wing in the 1950s. (Courtesy Ray Kinsey.)

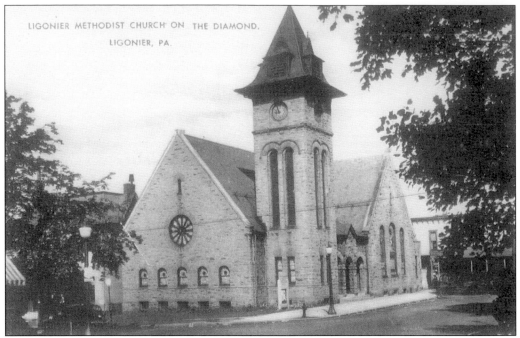

In 1857, the Methodist congregation moved to a brick church and parsonage at this location on the Ligonier Diamond at West Main and South Market Streets. Many in the church, including David Boucher, believed the site to be a more desirable location. The brick church was torn down in 1902. (Courtesy Doris Matthews.)

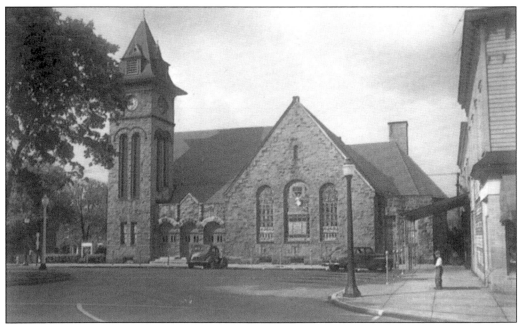

Bluestone for the new Methodist church was furnished by the Byers and Denny families, members of the congregation. This stone building, in the same location, at West Main and South Market, was dedicated free of debt in 1903. (Courtesy Doris Matthews.)

Four

AROUND THE VALLEY

Besides Ligonier, villages grew up in many spots around the Ligonier Valley. Usually they arose along a main traveling route, as with Laughlintown, or near one of the furnaces, as with Oak Grove and Waterford. Sometimes they grew up near coalfields, such as Wilpen. The Ligonier Valley Rail Road allowed the resources of the area to be more fully exploited, causing these small towns to grow. Even before the train arrived, many early settlers pushed to the outer reaches of the valley to establish their farms and homesteads. Families such as the Campbells, Slaters, and Ulerys were among them. Agriculture remains important to the valley, linking the present with the past.

There are many interesting sites beyond the bounds of the borough of Ligonier, sites that recall the history of the valley, such as Compass Inn. Much of the valley's industry took place in the hills and valleys outside Ligonier. A few of the old iron furnaces are still standing today. Most recreation also takes place outside of town, from Laurel Mountain on the east end of the Valley to Idlewild Park on the west, to the ridges and streams in between.

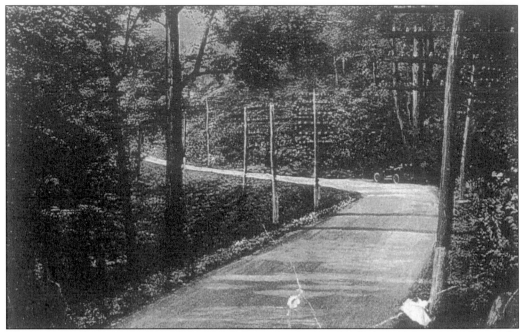

The western slope of Laurel Ridge is quite steep. Even after the (relatively) improved Lincoln Highway was built, the grade was still a challenge. The *1916 Road Guide to the Lincoln Highway* reminds drivers "the country is quite mountainous and care should be exercised. This means especial attention to tires, brakes, etc." Mountain Inn—about halfway up the mountain and located on a tight curve—served motorists whose cars had overheated or whose brakes needed a rest. Note, below, the Lincoln Highway marker on the pole at the right. (Courtesy Lincoln Highway Heritage Corridor.)

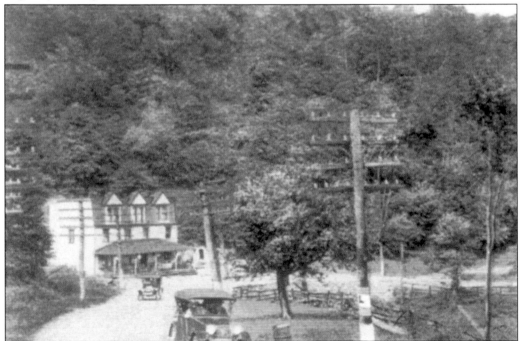

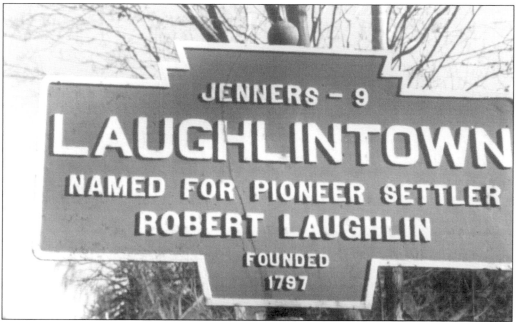

The Westmoreland Furnace Company opened near here in 1792. Robert Laughlin laid out this town in 1797. Located at the western base of Laurel Ridge, the town quickly became a stopover for those traveling the mountain. Originally named East Liberty, the town's name was changed when it got a post office. (Courtesy Bruce A. Shirey.)

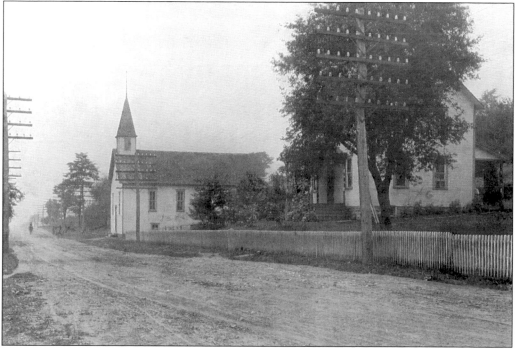

This street scene in Laughlintown shows the United Brethren Church and its parsonage. The photograph is dated 1910. Note the horse and rider and the buggy ruts down the street. (Courtesy Ligonier Valley Historical Society.)

The inscription on the back of the above view reads, "House in Laughlin's Town, Pennsylvania. September 10, 1908." The Yellow House Tavern (also called Naugle's Inn) was built in 1827. It was named after a tavern of the same name in Berks County. Joseph Naugle bought the property in 1833. The Yellow House was described as "one of the best wagon-stands and taverns" and Mrs. Naugle and her daughters as outstanding cooks. It is a private residence today. (Upper image courtesy Ligonier Valley Historical Society; lower image courtesy Bruce A. Shirey.)

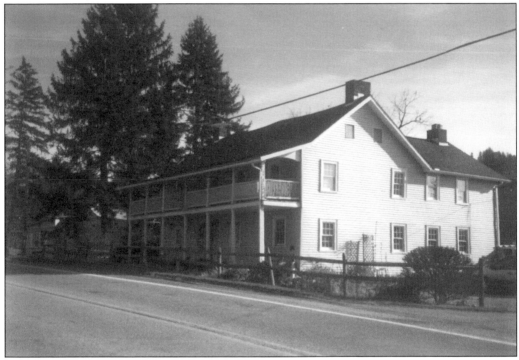

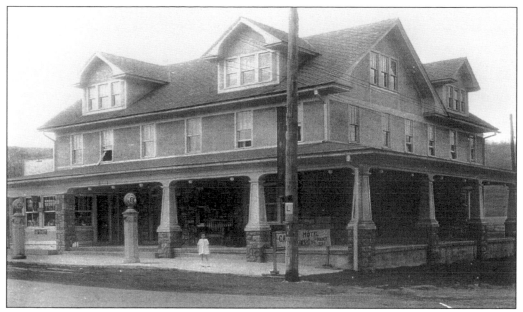

This Laughlintown inn and restaurant has served travelers for many years. Among its incarnations were the Laughlintown Hotel and the General Forbes House. Today, it is the Ligonier Country Inn. Note the Lincoln Highway marker in the view above. (Upper image courtesy Lincoln Highway Heritage Corridor; lower image courtesy Bruce A. Shirey.)

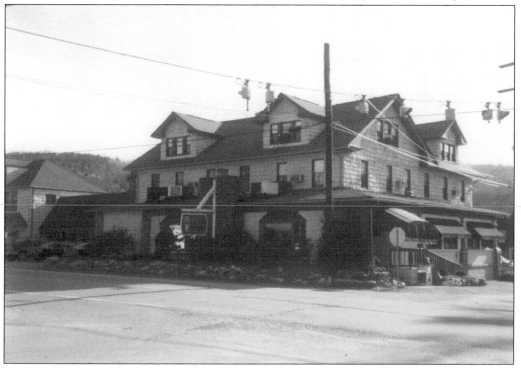

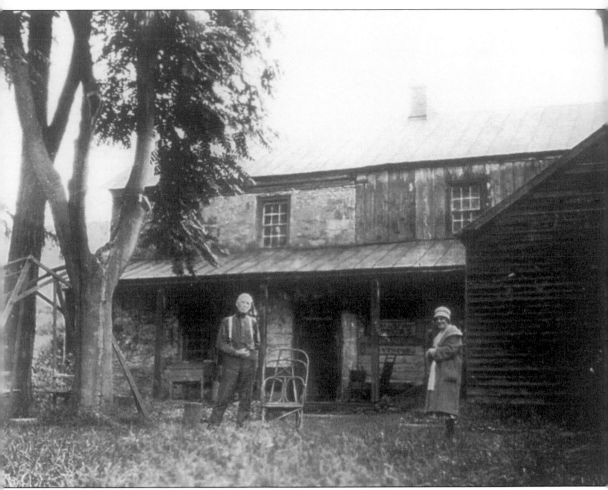

This photograph, dated August 27, 1927, was taken at the back of Compass Inn by a photographer from Pittsburgh. To the left is G.L.(?) Armor and to the right is Mrs. D.H. Johnston. Compass Inn has been a Laughlintown landmark since 1799, when Philip Freeman bought land from Robert Laughlin to build a tavern. The inn had changed hands several times before Robert and Rachel Armor purchased it in 1814. Over the years, seven generations of the Armor family lived here. Current innkeeper Lisa Hays is a direct descendant of the Armor family. (Courtesy Ligonier Valley Historical Society.)

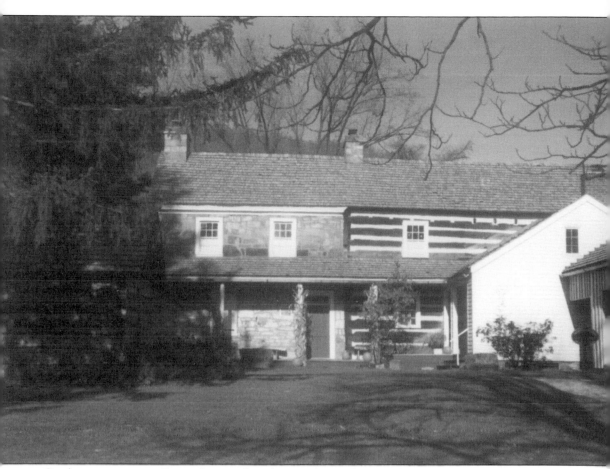

Settlers in western Pennsylvania found a ready market in the east for their livestock. As a result, cattle, swine, sheep, and fowl all crossed over the Laurel Mountain with human travelers. Inns along the route usually had fields and pens to accommodate the livestock overnight. Like Laughlintown in general, Compass Inn thrived until the mid-1850s, when the Pennsylvania Railroad drastically cut the number of travelers on the turnpike. The inn closed in 1862 and became a family home. This is a view of the restored Compass Inn today. (Courtesy Bruce A. Shirey.)

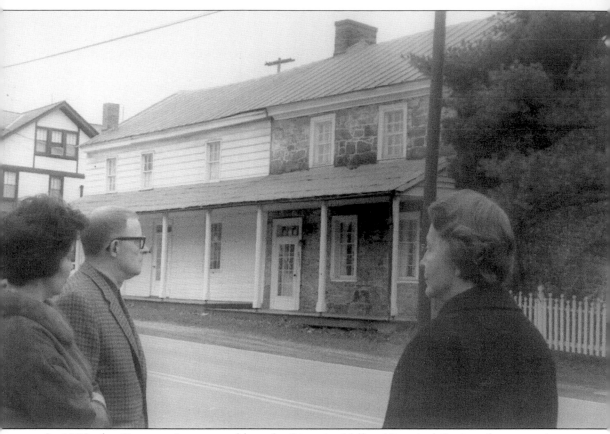

In 1966, the Compass Inn was sold to the Ligonier Valley Historical Society for use as its headquarters and a museum. Pictured are, from left to right, Mrs. Kenneth Craig, daughter of the inn's last owner, Virginia Swank; and Historical Society Board of Directors members Paul Mitchell, the chairman of the building and grounds committee, and Mrs. Thomas McCutcheon, the cochair of the membership committee.

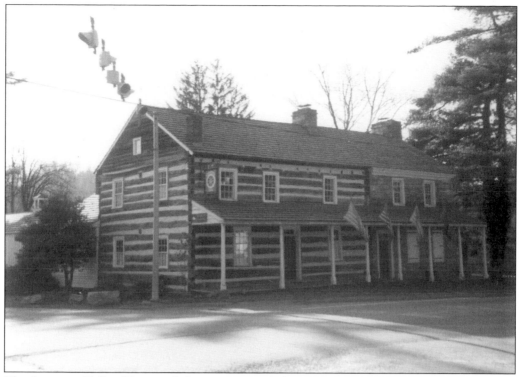

The Ligonier Valley Historical Society restored the Compass Inn to its 1830s appearance as a stagecoach inn. Restoration took six years, and the museum opened to the public in 1972. The inn has since been named to the National Register of Historic Places. (Courtesy Bruce A. Shirey.)

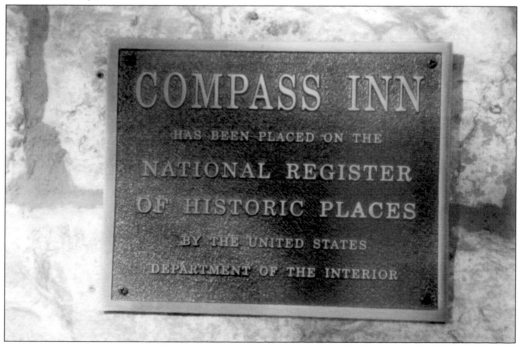

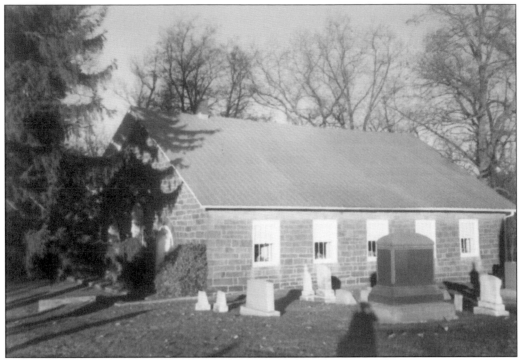

Formerly called the Old Donegal Church, Pleasant Grove United Presbyterian Church was organized in 1780. The name changed sometime between 1856 and 1859. The church was built in 1832 and rebuilt in 1892. The cemetery at the church contains the remains of many of the early settlers of the valley, namely members of the Campbell, Parke, Cavin, Cairns, and Withrow families. (Both images courtesy Bruce A. Shirey.)

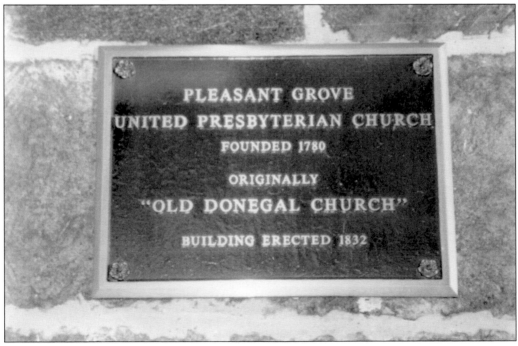

IN memory of
ROBERT CAMPBELL
Who died ... an
advanced age
The Deceased was one of the
early settlers of ... Valley
and with them su... red much
from Indian cruelt... In ...
1775, his Wife and Infant daughter
were barbarously murdered his
house burned, and the rest of his
Children, five in number taken
captives, one of whom never re...
...ed. A kind Providence restor...

One of the hazards for the early settlers was the threat from Native Americans. When Robert Campbell was a young man, his family was attacked. His mother, a baby, and a sister were killed. Native Americans took the remaining children north with them. The family was then separated. Robert Campbell was held for more than six years. He was finally able to return home in 1782, where he lived out a long life, dying at age 99. He is buried in the Pleasant Grove cemetery. (Courtesy Bruce A. Shirey.)

A United Brethren congregation was founded at Pleasant Grove in 1852. Their small brick church was built in 1857. The bricks were fired on site by the Phillippi brothers. The congregation became Evangelical United Brethren in 1946 and United Methodist in 1968. The small addition was built in 1991. (Courtesy Bruce A. Shirey.)

Throughout the valley, schoolhouses were built to educate the families in the nearby area. They were usually just one room buildings, with teachers who accommodated students ranging from first through eighth grades. This schoolhouse still stands at Pleasant Grove. (Courtesy Bruce A. Shirey.)

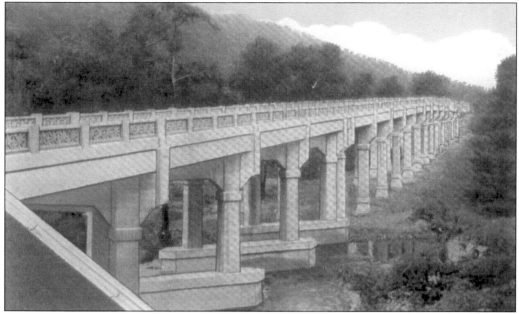

The Loyalhanna Viaduct, known locally as Longbridge, was built in 1925 by Pitt Construction in the area called McCance. The Ligonier Valley Rail Road line ran under the span, accounting for the slight hump in the center. Some 60 years old, it was dismantled in 1986 and a new bridge was constructed. Here, Donovan B. Shirey of Darlington surveys the demolition. (Upper image courtesy Doris Matthews; lower image courtesy Bruce A. Shirey.)

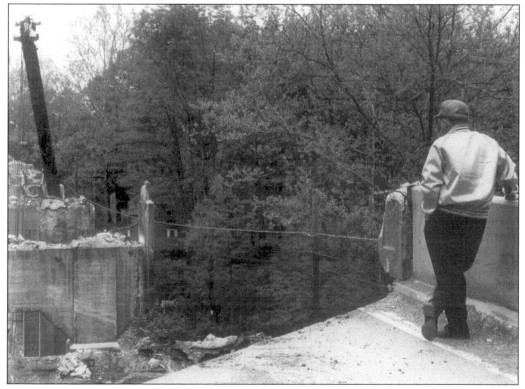

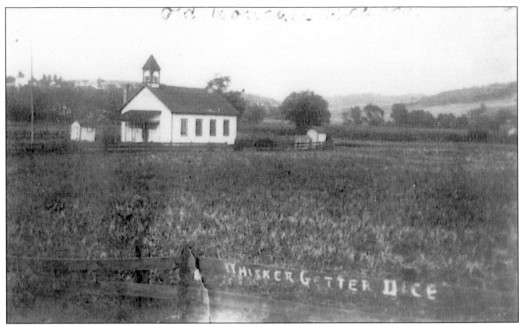

Boucher School was located just south of town near the present location of the Southern Alleghenies Museum of Art. Sam Dice, the local barber, often advertised by leaving graffiti around the valley. Notice his "advertisement" on the post rail. (Courtesy Ray Kinsey.)

This postcard, postmarked August 15, 1911, reports that "Ligonier is a popular resort for the people of western Pennsylvania. A bit of natural beauty typical of many to be found throughout the valley." The view, looking east, shows the Byers-Allen lumber mill in the background. (Courtesy Doris Matthews.)

Five

INDUSTRY IN THE VALLEY

Industry in the valley grew as a result of its geography and its natural resources of forests, streams, iron ore, and coal. The ridges were hilly and poor for farming, but they provided a good supply of lumber and stone. The interior portions of the valley were better suited for agriculture.

When the settlers first arrived, farming, by necessity, was their main concern. The first industries to develop were closely related to everyday life: millers, tanners, wagon makers, and merchants. Once the basics were taken care of, the natural resources could be exploited. Iron furnaces, gristmills, and sawmills all took advantage of those resources. Eleven iron furnaces operated in the valley. There was a handle factory on the western edge of town that could turn out some 65 bunches of handles each day, and there was a shop in Laughlintown that made barrel staves. The Pittsburgh Ice Company harvested ice from the small lake west of town. Robb Brickworks was located near the entrance to the Ligonier Valley Cemetery. The Ligonier Valley Rail Road allowed these and other businesses to grow. Today, there is little industry but many professionals and service providers.

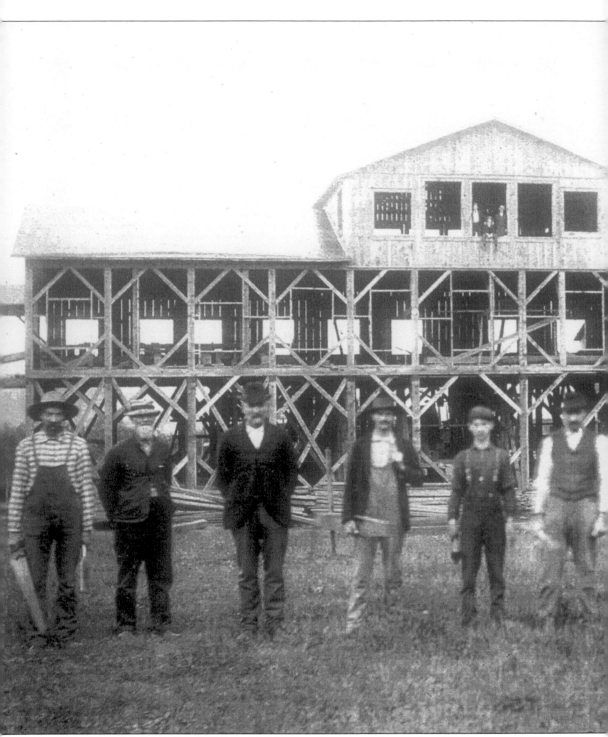

The ridges surrounding the Ligonier Valley were heavily timbered. In 1899, Byers and Allen built this lumber mill at the eastern edge of town to process the lumber being removed from Laurel Mountain. Unfortunately, the names of these workers were not recorded. The Pittsburgh, Westmoreland, and Somerset Railroad (PWS) was built specifically as a lumber carrier. The

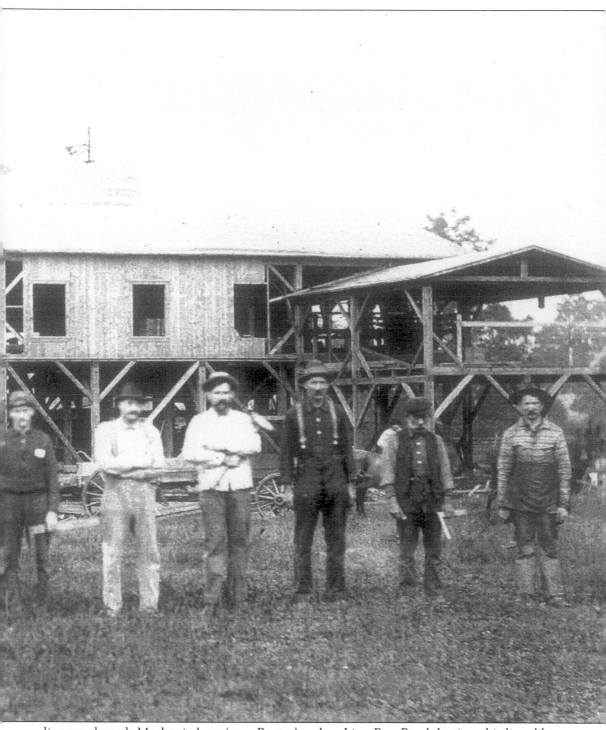

line ran through Mechanicsburg (now Rector) and up Linn Run Road. In time this line, like the Ligonier Valley Rail Road, also carried passengers. The supply of lumber quickly decreased. By 1910, Byers and Allen was selling off its land holdings to the state for $5 an acre. (Courtesy Ligonier Valley Historical Society.)

The Ligonier Valley had abundant supplies of the resources needed for iron production: iron ore, limestone for flux, and fuel, usually charcoal, which was made from wood and running water. The raw materials were thrown into the top of the furnace stack. Whenever it was feasible, iron furnaces were built near a bluff. This meant that only a short bridge was needed instead of elaborate scaffolding. Washington Furnace was built *c.* 1809 near Laughlintown. It supported a large village. Abandoned in 1826, it was rebuilt in 1848. Production continued until the mid-1850s. (Courtesy Ray Kinsey.)

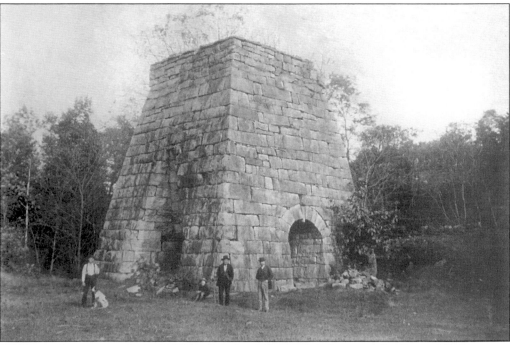

California Furnace was built 1850 by Col. Jacob Davies Mathiot and Dr. Samuel P. Cummins and was upgraded in 1858 by Alexander Cavin. Fire destroyed the company store and office, as well as a charcoal house. Cavin died bankrupt. This 1891 photograph shows Joseph (with dog), Martin Jr. with a dog, Joseph Martin Sr., ? West (or Weat), and Charles Armor. The stack has since been torn down. (Courtesy Ligonier Valley Historical Society.)

Iron furnace stacks could be some 30 to 40 feet square. Ross Furnace, built in 1814 by Isaac Meeson, remained in use until the mid-19th century. Pig iron, stoves, kettles, pots, and other items were made here. This photograph, taken in 1929, shows the Pennsylvania Railroad Dam in the background. (Courtesy Ligonier Valley Historical Society.)

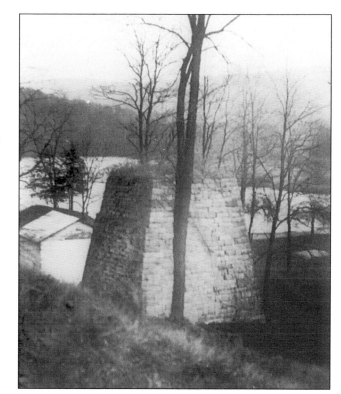

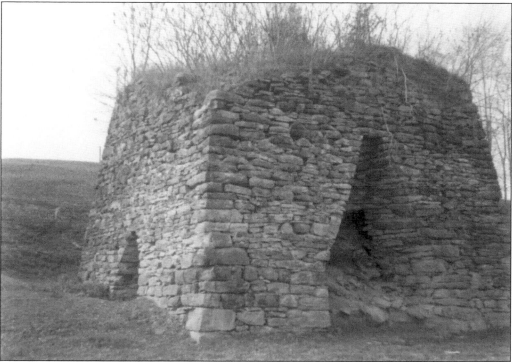

This is a current photograph of Valley Furnace. Built by L.C. Hall & Company in 1855, it was soon abandoned. (Courtesy Bruce A. Shirey.)

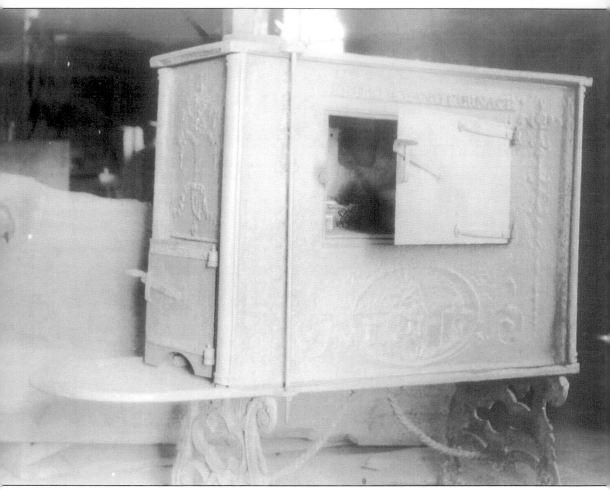

This stove was made at Westmoreland Furnace. The side of the stove casting reads "Vulcan, God of fine metals." The furnace was located about three miles from Fort Ligonier and one mile south of Laughlintown. The stove came from Elizabeth Shafer of the Willow Grove School District in November 1889. Willow Grove was located about two miles from where the stove was cast. In 1929, L.L. Armor of Laughlintown contributed the stove to the Western Pennsylvania Historical Society. The stove is now on display at Compass Inn, in Laughlintown. Westmoreland Furnace was the first in Westmoreland County. Built in the early 1790s, there was also a small forge and foundry located nearby. In 1795, stoves and castings made at the furnace were advertised for sale. During the War of 1812, grapeshot and canister shot were made there. The furnace was torn down in 1898. (Courtesy Ligonier Valley Historical Society.)

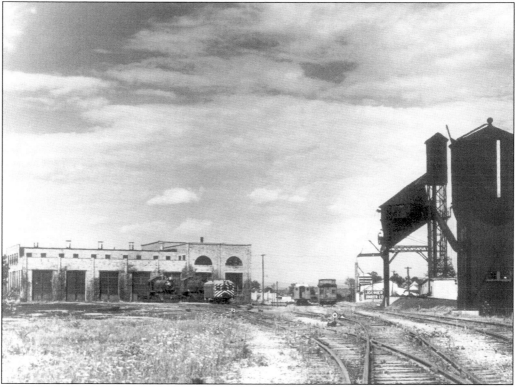

The valley's lumber, stone, and coal interests led to the development of the first local rail service. Established in 1853, the Ligonier and Latrobe Rail Road ran from the coal mines at Fort Palmer to Latrobe, where it connected with the main line of the Pennsylvania Railroad. (Upper image courtesy Bill McCollough; lower image courtesy Doris Matthews.)

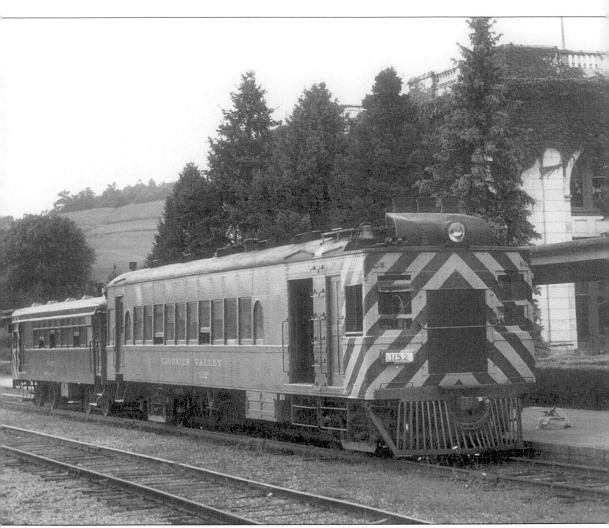

Still incomplete in 1871, the line was sold at sheriff's sale to Judge Thomas Mellon, who changed the name to Ligonier Valley Rail Road and expanded both passenger and freight traffic. The line was completed in 1877. The railroad increased the summer excursion traffic, and Ligonier became known as a destination. The town's largest growth occurred in the period from 1878 to 1920. Ligonier's first railroad station was located in a wood frame building off West Main Street. The depot moved to this stone building in 1910. On the first floor were the ticket office, baggage room, and waiting rooms. The second floor housed offices. (Courtesy Bill McCollough.)

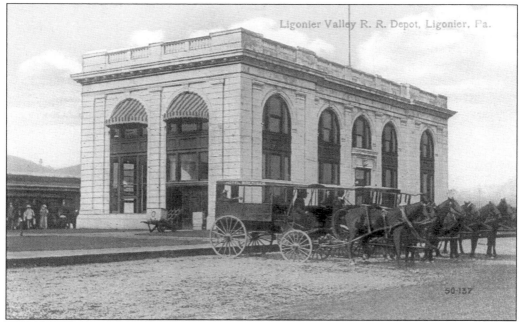

The upper card, postmarked July 1914, shows several livery wagons waiting to deliver arriving passengers to the area resort hotels. Jim Sibel and his son Roy ran just such a jitney service. Roy Sibel later became a partner in the Sibel-Wolford Funeral Home. After the Ligonier Valley Rail Road's last run in 1952, the Game Commission purchased the building for offices. The Southwest Division Headquarters is located here. (Upper image courtesy Doris Matthews; lower image courtesy Bruce A. Shirey.)

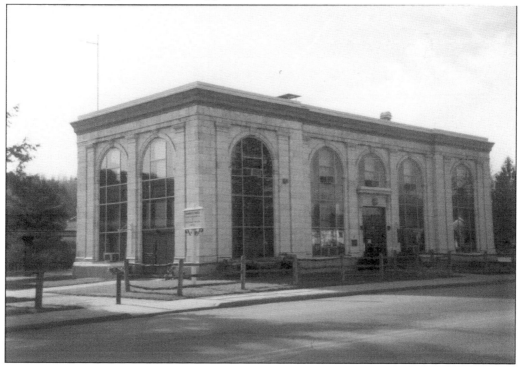

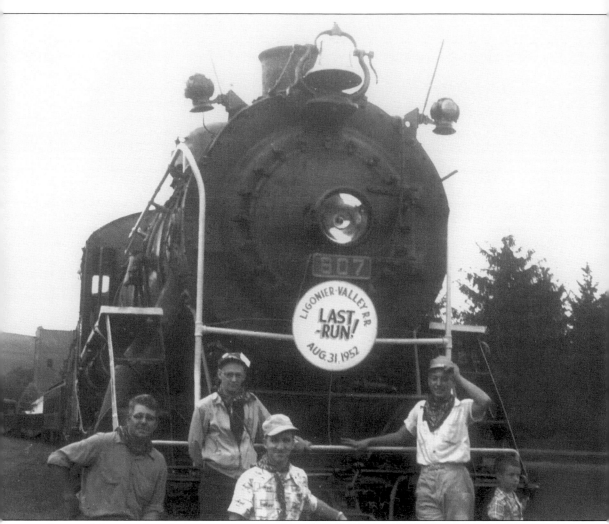

Automobile travel and truck transportation replaced train travel and, on August 31, 1952, the last run of the Ligonier Valley Rail Road took place. Here Tucker Frye, Dave Albert, Russ Lowden, Lester Turner, and an unidentified child stand with the engine the day of the last run. (Courtesy Bill McCollough.)

Six

LEISURE AND RECREATION

When Judge Thomas Mellon brought the railroad to town in the 1870s, Ligonier became known as a resort destination, not just a stopover. Guests then discovered what is still true today: the Ligonier Valley is prime recreation area. Its combination of history and natural beauty make it a popular spot for leisure activities. For the sports enthusiast, the valley is a year-round playground. State park and forest lands are open to the general public without charge and offer a wide variety of facilities and activities.

Among the sports available within the bounds of the valley are hiking, swimming, hunting, fishing, tennis, and horseback riding. There are several private and public golf courses. Winter sports options include sledding and cross-country and downhill skiing.

The Valley Players recently purchased the old movie theater for its home. If the group had been producing shows in 1889, it probably would have staged them at the Opera House on North Fairfield Street. The Opera House opened instead with Byron King, the head of the Curry School of Elocution and Dramatic Culture in Pittsburgh.

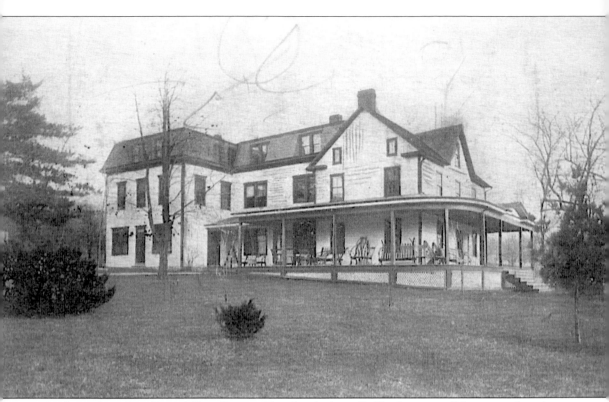

In the early 1870s, Daniel Kissell moved his family from Bedford to a small homestead in the Ligonier Valley near present-day Waterford. The area was popular with hunters and fishermen, who drank from the sulfur spring and sometimes stopped by the house to ask for a meal or a snack. This trend helped to create a boardinghouse which, as its popularity grew, became the Kissell Springs Hotel. Mrs. Kissell had a reputation for fine food. In its heyday, the dining room could seat 100 and was large enough to host winter dances and quilting parties. In October 1915, a fire destroyed the hotel and it was never rebuilt. (Courtesy Ray Kinsey.)

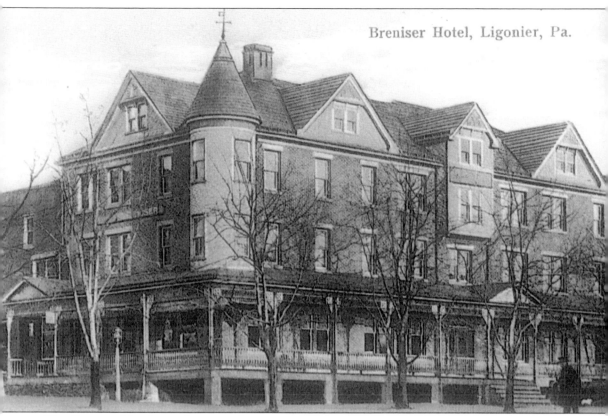

Breniser Hotel, Ligonier, Pa.

The Breniser Hotel was the most famous symbol of Ligonier's early tourist trade. The hotel flourished under the Breniser's ownership, becoming famous for its fine food and amenities. It was well known for its Sunday special: chicken and waffles for $1. Visiting salesmen set up their wares in the hotel to display to area businessmen. City boarders began arriving around May 1 and often stayed until November. The hotel declined through several changes of ownership and was torn down in 1967 as a part of the renovation of the Ligonier Diamond area.

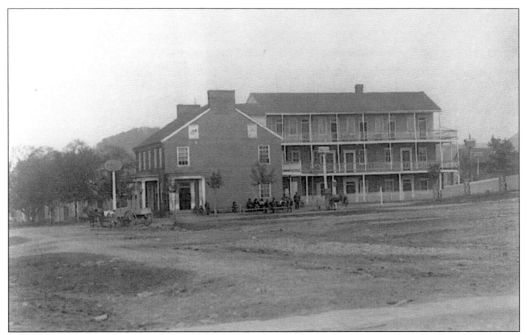

The Philadelphia–Pittsburgh Turnpike brought many travelers through Ligonier. Thomas Seaton built the Ligonier House in 1824. It sat on the northwest corner of the Ligonier Diamond, where the Ligonier Valley Library sits today. This stagecoach inn offered rooms for 25¢ a night, or 35¢ with clean sheets. In 1900, a third story was added to the front of the hotel and other improvements were made as well. The lower image was taken in 1908 during the sesquicentennial celebration. Note the purple martin house for feathered guests. (Courtesy Ray Kinsey.)

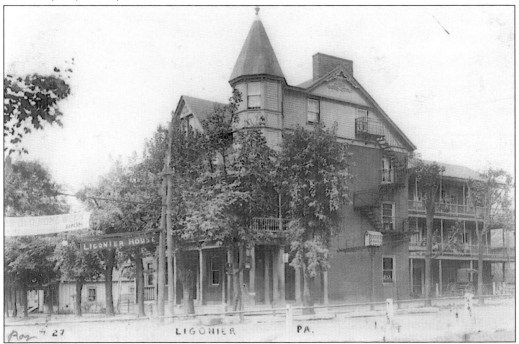

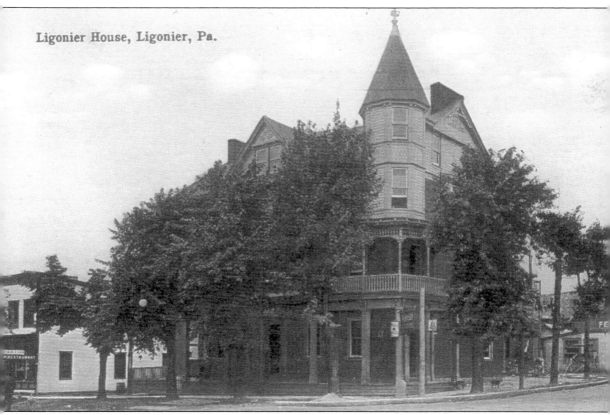

The Ligonier House specialized in caring for the business traveler as well as the summer boarder. It was also known as the Glessner Hotel. In June 1904, E.G. Nicely Jr., who was the proprietor of the Ligonier House, sold his livery stable to C.W. Clendening and W.S. Beatty of Pittsburgh. The livery stable can be seen to the right in this view. To the left of the hotel is the Ligonier Restaurant. Interestingly, this postcard had a return address of the Breniser Hotel. (Courtesy Doris Matthews.)

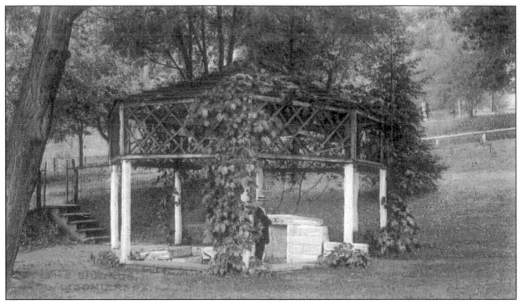

This postcard, dated 1913, shows Ligonier Springs. The springs were located between Loyalhanna Street and Route 30 below what is now the Ramada Inn. Many resort hotels were located near this spot. The Ligonier Valley Railroad had a stop near the springs. In 1890, John Hargnett Frank was finishing work on his hotel here. Later, the Ligonier Springs Hotel, the Hoffman Hotel, and the Fort Ligonier Hotel all sat on the site. More recently, a Holiday Inn, the Lord Ligonier Inn, and now a Ramada Inn have served travelers to the area. (Courtesy Ray Kinsey.)

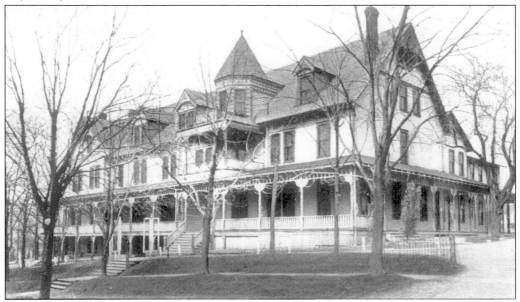

From 1903 to 1905, Dr. E.M. Clifford and Edward C. Price ran the hotel as a sanitarium. In 1904, Clifford advertised his Ligonier Springs Hotel-Sanitarium for those suffering from rheumatism, neuralgia, and other chronic diseases. Those patients not confined to their rooms could take treatments or baths there without residing at the hotel. Personal physicians were welcomed. (Courtesy Doris Matthews.)

FRANK'S HOTEL & COTTAGES

FRANK'S HOTEL & COTTAGES.

New and Strictly First Class. Beautifully situated. Special rates to Commercial travellers, and to Families remaining one week or longer. Baggage to and from Hotel Station free.

John H. Frank, Proprietor.
Ligonier Pa.

In 1890, J.H. Frank bought the Thomas McJenkins property to establish a summer resort hotel. An early advertisement (1900) notified guests that, "Frank's Hotel and Cottages at Ligonier, Pennsylvania, capacity 150, is now open for the season under the management of Mr. Harry P. Wyatt." Among the attractions were good food, abundant shade, elegant grounds, and pure mountain water. "On the grounds is a flow of excellent, cool and refreshing water, said to be impregnated with magnesia." Both the upper sketch and lower image show Ligonier Springs in the center. (Upper image courtesy Doris Matthews; lower image courtesy Ray Kinsey.)

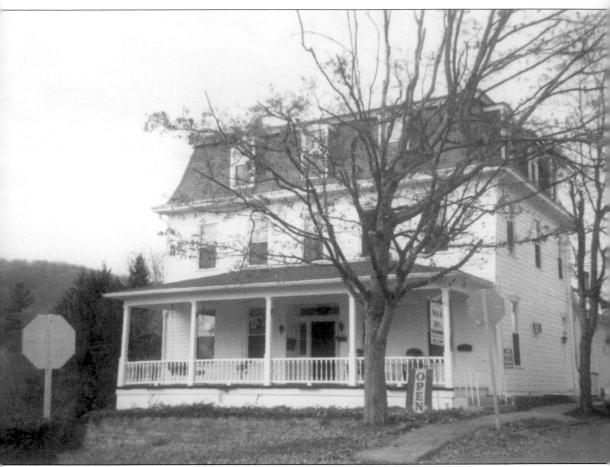

The Jacob and Nancy Frank House was built c. 1870. It served as a small hotel and boardinghouse. Nancy Frank was noted for her fine cooking. She often left out an ingredient when asked for her recipes. In 1915, the property was acquired by the family of June Smith Millison, who opened the Town House restaurant in 1951. Over the years since the restaurant closed, several retail establishments have occupied the place. (Courtesy Bruce A. Shirey.)

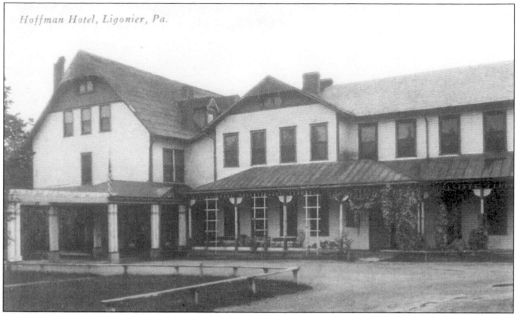

Both of these hotels are later incarnations of the Ligonier Springs Hotel. (Both images courtesy Doris Matthews.)

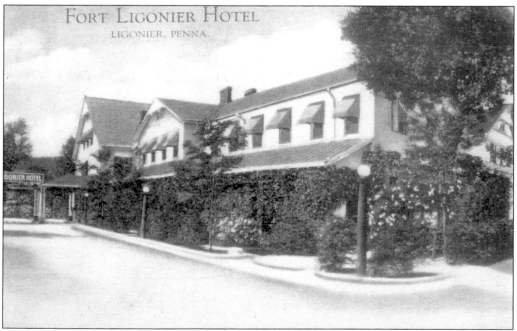

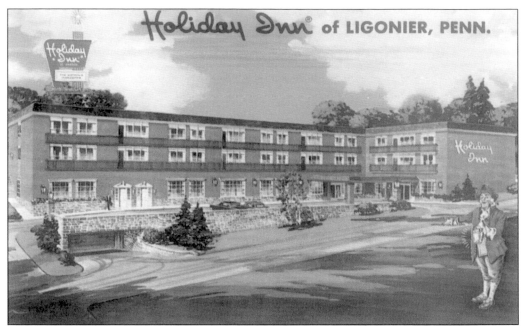

In the 1960s, a modern Holiday Inn was built on the site of the former resort hotels. (Courtesy Doris Matthews.)

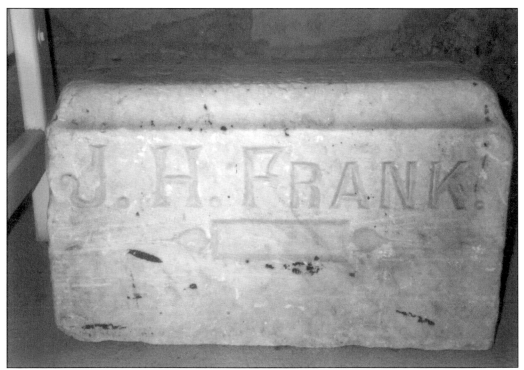

This stone, with its inscription for John Hargnett Frank, sits today at the Ramada Inn entrance. (Courtesy Bruce A. Shirey.)

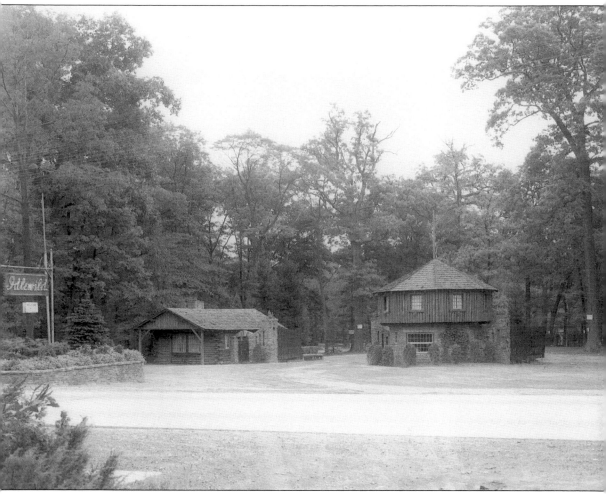

In 1878, William Darlington granted Judge Thomas Mellon of the Ligonier Valley Rail Road the right to use his land—some 400 acres on the Loyalhanna Creek—"for picnic purposes or pleasure grounds." With this agreement, the development of Idlewild Park began. Many additions were made over the years and the park remains one of America's most beautiful amusement parks. (Courtesy Ligonier Valley Historical Society.)

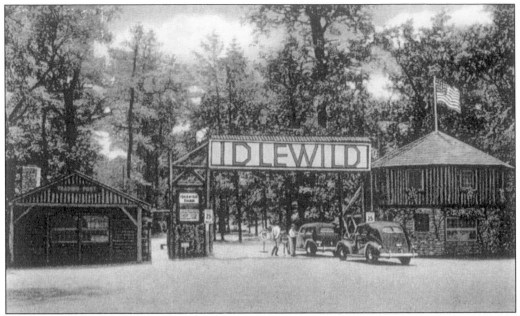

Idlewild Park is one of the oldest continuously operated parks in the country. It began as an end-of-the-line picnic area created by the Ligonier Valley Rail Road. Trains and, later, trolleys provided passenger service to the park. (Courtesy Lincoln Highway Heritage Corridor.)

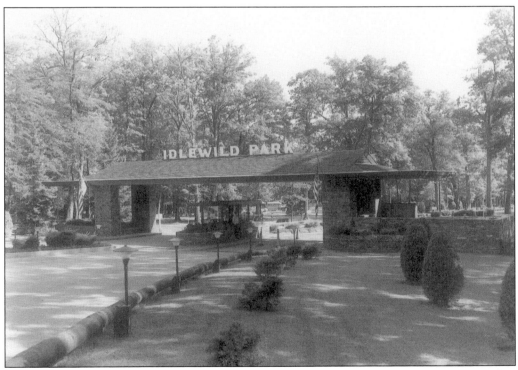

This entrance to Idlewild Park was completed in 1958. (Courtesy Ligonier Valley Historical Society.)

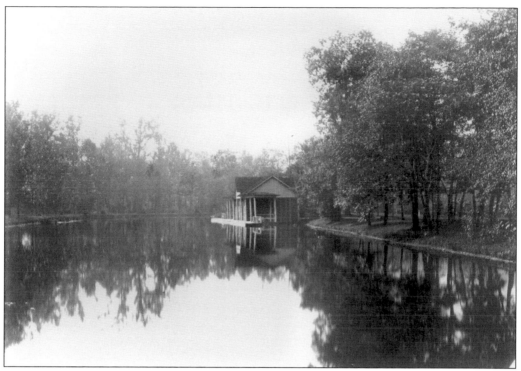

In 1899, an artificial lake was added for boating and fishing. The upper image shows the boat house, and the lower image shows some boaters enjoying a summer day. (Upper image courtesy Ligonier Valley Historical Society; lower image courtesy Idlewild Park.)

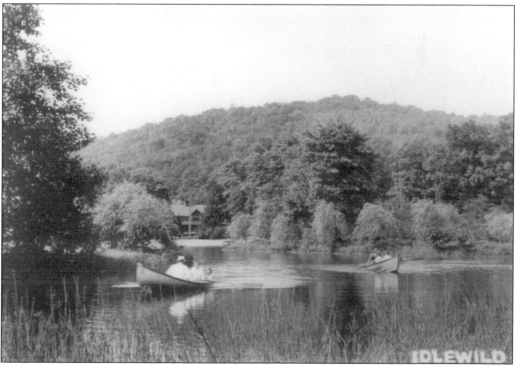

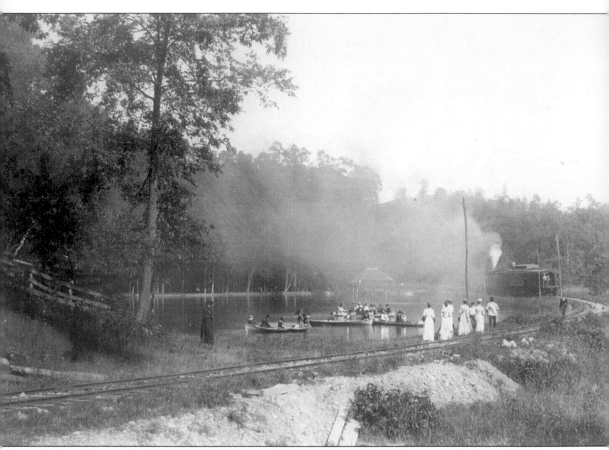

Judge Thomas Mellon and the Ligonier Valley Railroad actively promoted the park and its mountain setting. In this photograph, showing the lake from the west, a group of picnickers walk along the rail bed. (Courtesy Ligonier Valley Historical Society.)

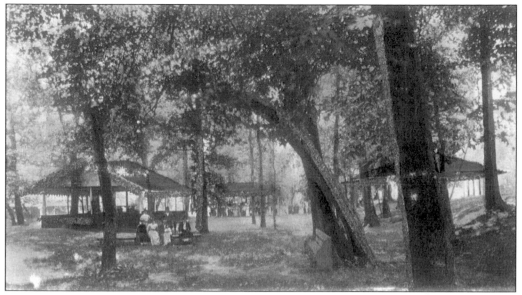

Judge Thomas Mellon advertised the park to schools, churches, and businesses, especially in the Pittsburgh area. He touted the park's beautiful, open setting. Music was especially important at the park. In 1900, the Ligonier Silver Cornet Band played at the Reformed reunion picnic. At the 1910 Ligonier Valley Reunion, the McColly Band of Latrobe and the Keys Orchestra played at the Dance Pavilion. (Both images courtesy Doris Matthews.)

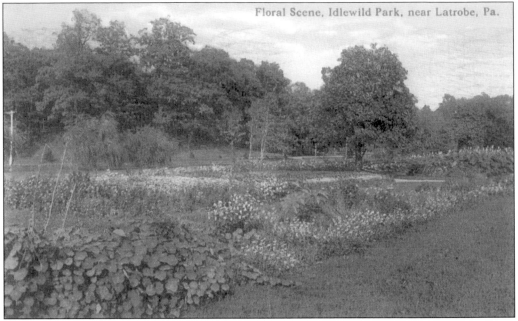

Floral Scene, Idlewild Park, near Latrobe, Pa.

A hallmark of Idlewild Park are its shady groves and gardens. (Upper image courtesy Doris Matthews; lower image courtesy Idlewild Park.)

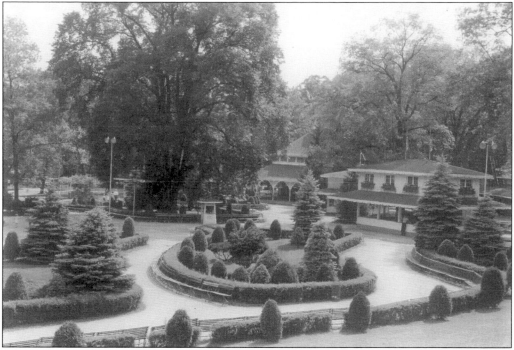

These manicured gardens show why Idlewild Park has been called America's Most Beautiful Recreational Park. (Courtesy Idlewild Park.)

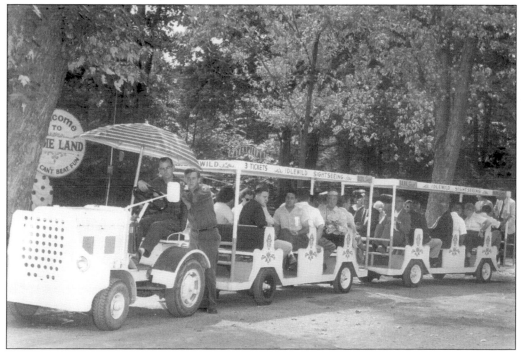

In the early days of the park, tickets were purchased from the park and then used as payment for the amusements. This sightseeing tram traveled throughout the park. It cost three tickets to catch a ride and was considered well worth it after a long day. (Courtesy Idlewild Park.)

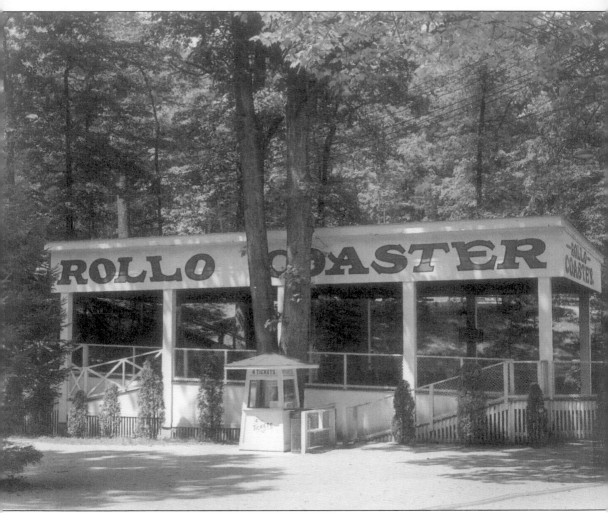

In 1931, C.C. Macdonald and Richard B. Mellon (son of Judge Thomas Mellon) became partners in Idlewild Management Corporation. Their goal was to make improvements to the park. Among those improvements were amusement rides, picnic pavilions, and a pool. (Courtesy Ligonier Valley Historical Society.)

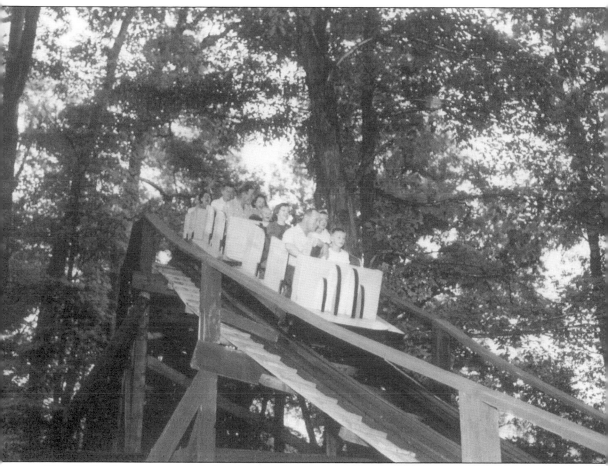

The Rollo Coaster is one of the classic rides in the Olde Idlewild section of Idlewild Park. Built by the Philadelphia Toboggan Company, the ride opened here in 1938. Two trains run along a wooded hillside before returning to the station. The Rollo Coaster has been named an American Coaster Enthusiasts Classic Coaster and continues to thrill riders today. (Courtesy Ligonier Valley Chamber of Commerce.)

Ligonier Valley Reunion

On Thursday, August 21, 1924
Thirty-third Annual Reunion of Ligonier Valley People
AT IDLEWILD

You and your friends are respectfully invited to attend this gathering and help make it a success and enjoy its pleasures. Come, your friends and neighbors will expect to meet you at Idlewild.

Idlewild Park quickly became a popular location for reunions, school picnics, church gatherings, and community events. The Ligonier Valley Reunion was begun in 1893. It continues today as the Ligonier School and Community Picnic. (Upper image courtesy Ray Kinsey; lower image courtesy Idlewild Park.)

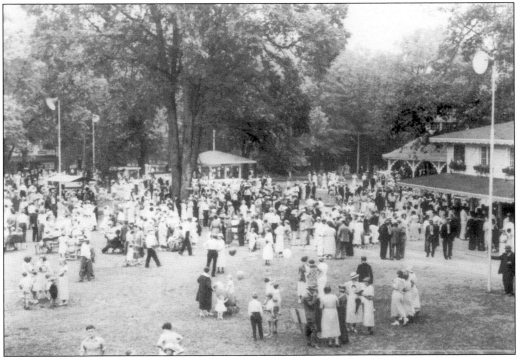

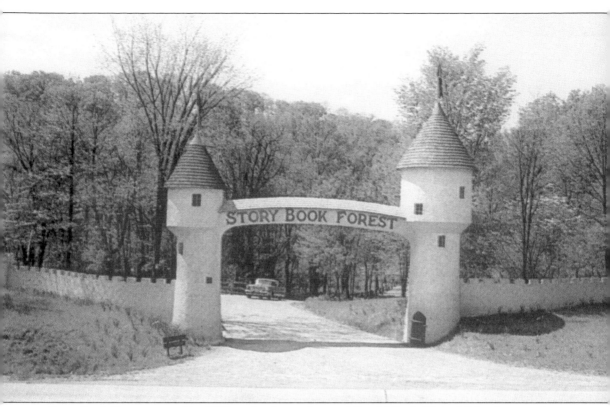

Story Book Forest opened in 1956 on land next door to Idlewild Park. This children's attraction is based on well-known storybook characters. Vignettes show the Three Men in a Tub, the Good Ship Lollypop, Snow White and the Seven Dwarfs, and many other beloved creations. Kennywood Park Corporation bought both Idlewild Park and Story Book Forest in 1983 and integrated them into a single attraction. This postcard, dated 1960, shows the old entrance to Story Book Forest. (Courtesy Ray Kinsey.)

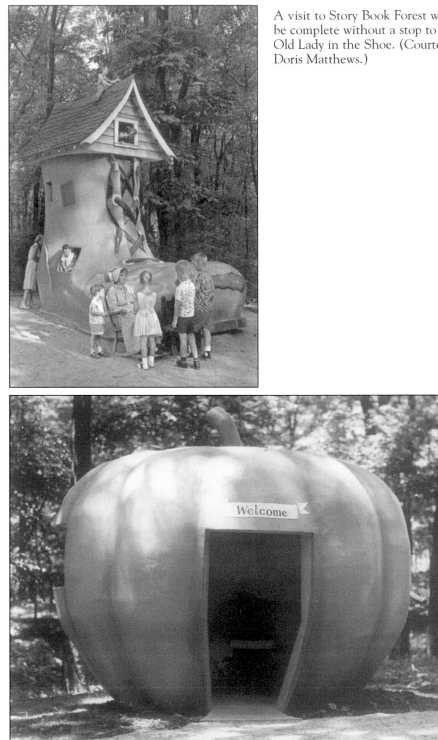

A visit to Story Book Forest would not be complete without a stop to see the Old Lady in the Shoe. (Courtesy Doris Matthews.)

Children of all ages can find out what it is like to be kept in a pumpkin shell. (Courtesy Idlewild Park.)

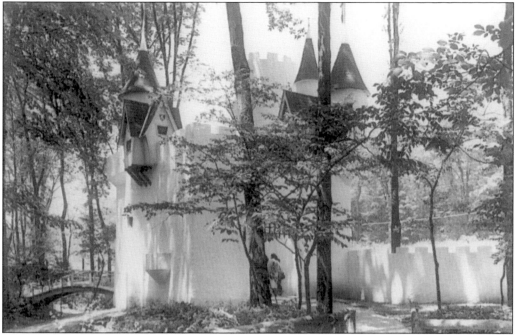

Once home to a talking knight, the Enchanted Castle has been torn down to facilitate traffic flow through the park. (Courtesy Ray Kinsey.)

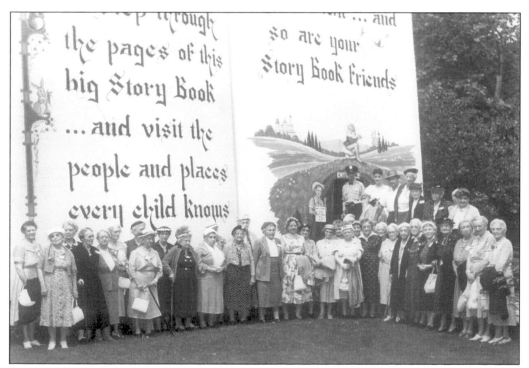

A group of women from the Presbyterian Home prepares to revisit childhood friends. (Courtesy Idlewild Park.)

The Ligonier Valley Bathing Beach opened on July 4, 1925. It is some 400 feet long and 125 feet wide. It featured a man-made sand beach and dances at the pavilion. Before he became famous as Dean Martin, Dino Crocetti performed here. (Courtesy Doris Matthews.)

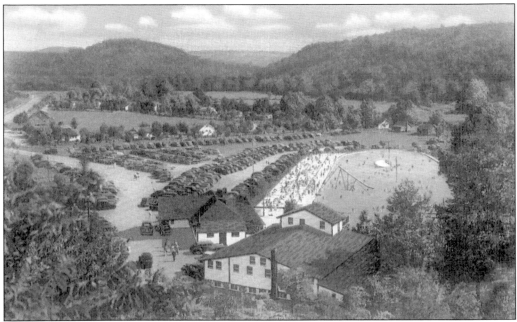

This postcard notes, "Ligonier Valley Beach located one-half mile east of Ligonier Pennsylvania on the Lincoln Highway is noted for its most beautiful scenic location and afford not only a good place to spend a day, but a chance to swim in pure mountain water. In the background can be seen the Laurel Mountain range of the Allegheny Mountains." Seventy-five years after it opened, the beach still attracts swimmers from around the region. (Courtesy Doris Matthews.)

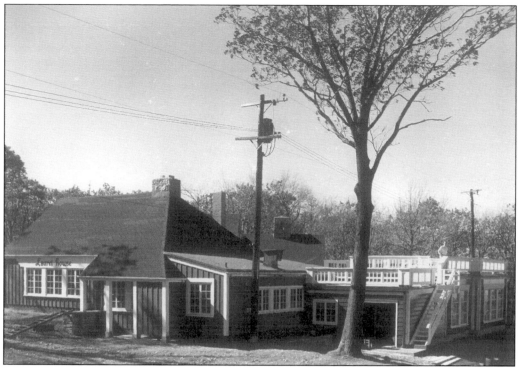

In 1939, Richard King Mellon realized that the steep terrain of the valley would make a good ski resort. He hired Hannes Schneider to design one. Laurel Mountain Ski Resort opened in the winter of 1940. Laurel House Lodge, overlooking the slopes, was built in 1941. The lodge had food service and a ski shop. In the early 1960s, a bar and restaurant were added. Laurel House burned to the ground in 1969. (Courtesy Ligonier Valley Historical Society.)

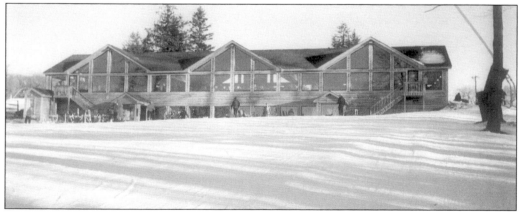

In 1963, Mellon gave the ski area to the Commonwealth of Pennsylvania on the condition that it be used for recreation. Through the years, the state and various private lessees attempted to operate the resort, but the facility closed in 1990. The resort reopened with a new lodge and support building in 1999, to the delight of area downhill ski enthusiasts. (Courtesy Laurel Mountain Ski Resort.)

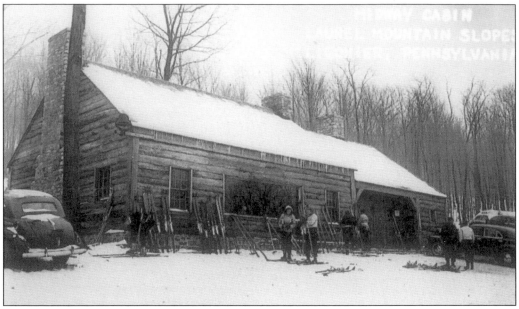

Midway Cabin was the original ski lodge built at Laurel Mountain Ski Resort. Travelers reached it by way of Locust Camp Trail. Its single lane did not hinder buses bringing skiers to the resort. (Upper image courtesy Ray Kinsey; lower image courtesy Doris Matthews.)

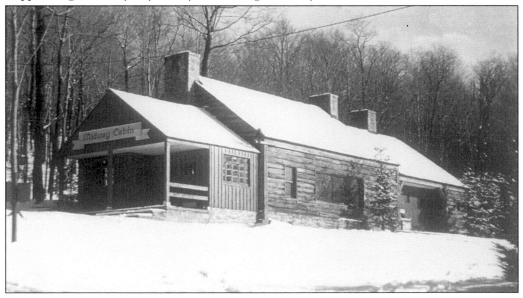

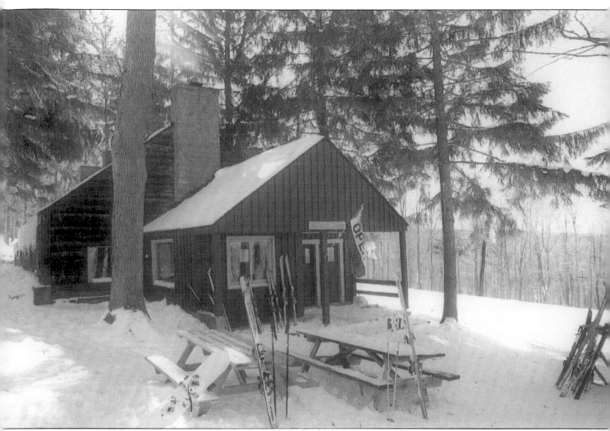

Midway Cabin is still in use today. This 1999 photograph shows that snowboards have joined skis on the slopes. (Courtesy Laurel Mountain Ski Resort.)

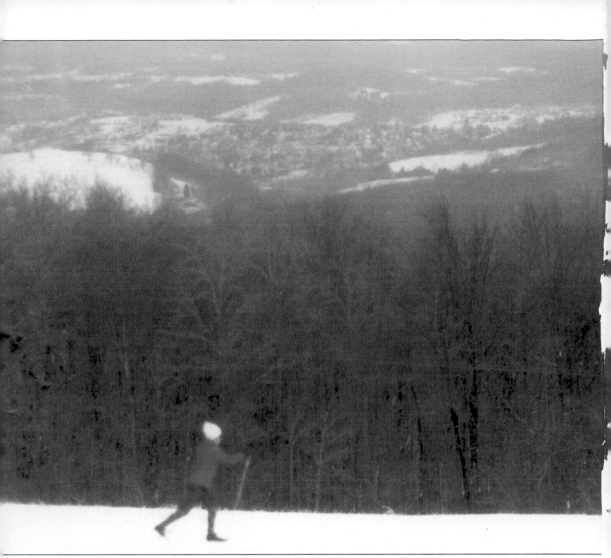

A cross-country skier enjoys the serenity of a snowy afternoon. This photograph was taken on Chestnut Ridge, overlooking Ligonier and the valley. (Photograph by Ted Steiner, courtesy Ligonier Valley Historical Society.)